CW01183284

Venice
CA

Venice CA

Art + Architecture in a Maverick Community

Text by Michael Webb

Photographs by Juergen Nogai

Abrams, New York

Contents

6 **Introduction**

12 **Artists at Work**

Ed Ruscha
Billy Al Bengston
Larry Bell
Ken Price
Alexis Smith
Ed Moses
Laddie John Dill
Guy Dill
Chuck Arnoldi
Huguette Caland
John Baldessari
Kim Schoenstadt
Kristin Klosterman
John Okulich
Lynne Hansen
William Attaway
D.J. Hall
Robert Graham
Juan Carlos Munoz

22 Adventurous Architects

28 Walk Streets
Japanese Intensity
Playful Simplicity

38 Canal Houses
Colorful Transparency
Material Invention
Floating Geometries
Incremental Improvements

52 Oceanfront Living
Lifeguard Redux
Light-filled Aerie
Panel Game

64 Looking Inward
Pointing Skyward
Soulful Simplicity
Work in Progress
Open to Nature
Minimal Loft
Sensuous Laboratory
All That Jazz
Concealed Openings

100 Additions and Remodels
Green Showcase
Frugal Artistry
Trailer Treasure
Spatial Illusions
Big Lift
Playing the Angles
Mail-Order Idyll
Corrugated Cube
Flexing Muscles

136 Living with Art
Graham and Friends
Masks and Rocks
Mosaic Tile House
Time Warp
Quirky Figures
Clustered Cottages
Color Field
Glass and Fashion
Reclusive Savant
Master Printer
Art Mecca
Cabinet of Curiosities

182 Creative Spirits

Charles and Ray Eames
Tom Schnabel
Michael Fox
Elena Manferdini
Tony Bill
Jay Griffith
Jo Lesoine
Matt Danciger
Alan K. Barnett and Melissa Davies
John Peed
Jack Hoffman

187 Resources

189 Acknowledgments / Credits and Index

Introduction

There are no art-filled palaces or Palladian churches in Venice, California, and most of its canals were long ago filled in. The Italian Venice, justly called *La Serenissima*, was built up over a millennium, and great wealth produced enduring beauty. The Pacific Coast version was erected in a few years, experienced brief popularity and a long decline, staying poor and neglected until the 1990s.

On the surface, it appears unremarkable—battered warehouses and rustic streets lined with wood-frame cottages—yet it is far more creative and alive than its fancy forebear, which has become a hollow shell kept afloat by an unrelenting wave of tourists.

The American Venice is a congenial small town, where residents chat with friends and neighbors as they walk or bike around, coexisting with a hood in which gangs face off and bullets fly. It's the West Coast equivalent of New York's East Village, one of the last places on the affluent west side of Los Angeles where rich and poor, black, white, and Hispanic still live side by side and do pretty much what they want. "Venice is a real place," says artist Chuck Arnoldi, who arrived in the 1960s. "I like wrinkles. When people smile I want to see their faces crease. Marina del Rey [a planned development to the south] is *Stepford Wives*."

The community is fertile ground for mavericks. Two artists have covered every inch of a plain 1940s house with a mosaic of multicolored tiles and splintered glass. On another street, four tiny cottages in brilliant colors have been linked and a bathtub sits outside under a galaxy of glass lanterns strung from the trees. Julia Roberts has forsaken movie-star glamour to live in a modestly scaled house on a leafy side street. Dennis Hopper put a white picket fence around his corrugated steel compound. This is not your conventional white-bread suburb and, though gentrification is under way, there's none of the suffocating primness of other beach communities.

Venice comprises a square mile of the sprawling city of Los Angeles, extending inland from a broad sandy beach. Most visitors know only the rambunctious boardwalk (recently enhanced by a Mark di Suvero construction), crammed with babes on blades, tattooed exhi-

Sea, sand, and surf: three timeless elements in a community that has changed radically over the past hundred years.

bitionists, exotic entertainers, sidewalk peddlers, and wide-eyed tourists. It's a five-block carnival—a throwback to the early years. Behind that gaudy mask is the real Venice. Blank facades, some scarred with graffiti, conceal spacious studios that serve postproduction wizards and recording engineers as well as painters and sculptors. The ground is flat and a thirty-foot height limit allows you to look over the roofs and palm trees to the ocean and mountains from every roof deck. The mix of overhead wires, corrugated metal, and plywood interspersed with houses in many fanciful styles, gives it the quality of a collage—an urban artist's work in progress.

Some of the best art in America is still being made in Venice, and adventurous architects have followed, building tough, unpretentious houses for themselves and other free spirits. Artists inspired Frank Gehry to forge a new language of architecture and, after moving away and achieving international fame, he is designing a new house for his family in Venice. Thom Mayne, another Pritzker Prize–winning architect made his debut here as a founding partner in the firm Morphosis. Arata Isozaki and Coop Himmelb(l)au have made idiosyncratic contributions, and Maya Lin is completing a characteristically understated house

on a walk street near the beach. Avant-garde architect Greg Lynn used computer software to design a house that resembles a loosely coiled spring.

Ironically, the presence of artists and high-profile architects has encouraged the less adventurous to think of moving to Venice. Soaring real estate values are luring greedy carpetbaggers who build overscale complexes of so-called artists' lofts. Modest cottages, ramshackle but charming, are being replaced by lumpish, high-priced packing cases. There are plenty of residents who are ferociously loyal to the spirit of place and are fighting back. However, their efforts to channel and moderate new development are being undercut by aging '60s activists, still dreaming of revolution and stubbornly opposed to any change.

Until 1904, the area was a swamp—its most authentic link to the origins of the other Venice. Abbot Kinney, a tobacco tycoon–turned-developer, had a fanciful vision of transforming this wasteland into a picturesque hybrid of entertainment and high culture. Inspired by his travels in Italy, he took Venice as a model, and commissioned a master plan from architect Norman F. Marsh and his associates. They were inspired by the 1893 World's Columbian Exposition in Chicago, with its central lagoon, historicist buildings, and Midway *plaisance*. Coney Island and other East Coast amusement parks provided a model for rides and exotic structures on the pier. An arcaded street (now Windward Avenue) linked the pier to a lagoon and a radiating network of canals. From opening day on the Fourth of July

Windward Avenue in 1904 and today: one of the few surviving fragments of Abbot Kinney's vision of an American Venice.

A much faded mural by Terry Schoonhoven provides a mirror image of Venice and the distant San Gabriel mountains to the east.

1905, the public flocked to the beach and boardwalk, jamming the carnival, camel rides, and imported gondolas. The Ship Café, dance hall, and bathhouse flourished, but high-minded lectures fell on deaf ears and Kinney lowered his sights.

In *Venice of America: Coney Island of the Pacific*, local historian Jeffrey Stanton chronicles the checkered history of the carnival attractions, which peaked in the early 1920s and, after a succession of devastating fires and storms, expired when the pier was torn down in 1947. The resident population soon rose to ten thousand, and this number grew in summer when Angelenos moved to weekend and summer cottages. Sewage, water, and paved roads all proved inadequate, and reforms were stalled by factionalism. A referendum to annex the city to L.A. narrowly failed in 1923 but was approved in 1925.

In the 1920s, young people were mad for speed, and though they depended on the Red Car light-rail to downtown and the spur to Santa Monica, residents were impatient of the delays. They were eager to drive their new automobiles and some felt as humorist Robert Benchley did, when he visited *La Serenissima* and cabled his New York editor: "Streets full

of water. Please advise." Kinney deeded the canals north of Venice Boulevard to the city, which proposed to fill them in. The move was long delayed but swiftly accomplished in 1929. By then, they had become stagnant and garbage strewn. Expansive Windward Circle replaced the lagoon, and the canals generated a few broad avenues that contrast with the narrow walk streets leading off Lincoln Boulevard and Ocean Front Walk.

The oil boom of 1930–31 contributed little but pollution. The canals south of Venice Boulevard would have been filled in had their few residents been able to afford the assessment. Kinney's vision slowly faded away, and the boardwalk, once thronged with pleasure seekers, was left to a handful of retirees when the pier was torn down. "Like San Francisco's North Beach, Venice became a tumbledown mecca for the hip, the poor, and the alienated," wrote social historian Stephen Rebello.

Artists and writers lived side by side with Hells Angels, drug dealers, and the homeless. Lawrence Lipton celebrated the Beat Generation in *The Holy Barbarians* and the reclusive writer Thomas Pynchon is rumored to have holed up here while writing *Gravity's Rainbow*. In 1957, Orson Welles made *Touch of Evil*, re-creating a sinister Mexican border town by filming at night amid the arcades and oil derricks. During the location shoot, the three-hundred-pound Welles tumbled into one of the canals, and a key scene is staged beneath a creaking bridge. The same locations appear almost as desolate by day in *Cisco Pike*, a 1972 feature starring Gene Hackman and Kris Kristofferson. French filmmaker Agnès Varda captured the vibrancy of the first generation of muralists, especially the L.A. Fine Arts Squad, in her documentary *Murs, Murs*. Sadly, the best of these have faded away or have been vandalized beyond repair.

Miraculously, Venice was left to fester at a time when planners were receiving federal subsidies to tear down decaying neighborhoods in the name of urban renewal. In L.A., the old residential core of Bunker Hill was leveled in the early '60s, and replaced by a sterile corridor of office towers. The authorities did crack down on substandard commercial buildings around that time, and many landlords chose to demolish rather than pay to bring them up to code. A notable casualty was the oceanfront Gas House, a decrepit hangout for Beat writers. In 1961, property owners petitioned the city to dredge, widen, and pave the Venice canals and link them with those in newly developed Marina del Rey. The mayor supported this proposal and more ambitious schemes to redevelop the waterfront, but local opposition stalled the destruction.

Artists at Work

Young artists, fresh out of school, gravitated to Venice from the late 1950s on, in search of abandoned buildings, surfing, and the company of friends. "Downtown, all I got was cheap rent—no street life," recalls Chuck Arnoldi. "I suffocated in summer and froze in winter. In Venice the air was fresh, I rented a 12,000-square-foot loft for almost nothing, and it was a place beyond the law.

A community of artists and like-minded misfits—dealers, the homeless, rock stars, Beat poets, and musicians. There were about twenty artists and when anyone had a show or a party, everybody showed up. We talked and argued about art all the time; everyone had a different opinion and tried to do better than everyone else. I could sense the energy and the beauty of living by the ocean."

"The '70s were great," says Guy Dill. "At one point all of us would hang out on the beach and then go back to our studios. We'd inevitably see each other at night. We were all good friends, and yet we had no collective identity—we were all individual artists." Robert Irwin called L.A. "one of the least restrictive towns in the world . . . it's such a great place to do art and build your ideas about culture."

John Altoon, George Herms, Wallace Berman, Peter Voulkas, and Richard Diebenkorn were among the pioneers. Robert Irwin, James Turrell, Larry Bell, and others settled on Market Street and Bell is back in the studio he first rented in 1964. Billy Al Bengston and Ken Price share a studio building on Mildred Avenue, Ed Ruscha and Laddie John Dill work in adjoining properties on Electric Avenue, John Okulich on Hampton Drive, and Guy Dill around the corner on Innes Place. Some of the key figures have moved—Irwin to San Diego, DeWain Valentine to Gardena, Peter Alexander and Tony Berlant to Santa Monica. Others have homes as far afield as Taos or Vancouver, but return to spend a few weeks or months working in a neighborhood that still speaks to them as it did in their formative years.

"The young artists who came out of Chouinard and Otis [art schools] in the 1950s represented the first generation who studied in L.A. and made it their home," says veteran curator Henry Hopkins. "They were shown at Ferus

[a seminal gallery founded in 1957 by Ed Kienholz and Walter Hopps], and did anything to support themselves that didn't conflict with their art. Irwin made his money at the racetrack using his selective betting system. Venice artists were highly competitive, and the camaraderie persisted as long as it did because nobody was getting rich."

The quality of the light and the emptiness of Venice in the early years fed into the Light and Space movement, which reached its apogee in the minimal environments of Irwin, Bell's glass boxes, the luminous planes of Doug Wheeler, and the experiments of Turrell. The rough-edged, hands-on character of the community inspired a kind of *arte povera*. Ed Kienholz was a major influence on the assemblages of Bruce Conner. As a biker, Bengston was drawn to the "finish fetish" of customized gas tanks, and a few of his peers picked up on this and created shimmering, translucent sculptures of resin and acrylic.

The Venice art scene snapped into focus only when viewed, through the wrong end of a telescope, by critics and curators in New York. Close-up, it was intuitive and experimental, uninfluenced by critical theory or a dominant figure, and largely neglected by the local establishment. The Ferus closed in 1966, the Pasadena Museum of Art was absorbed by the Norton Simon Collection in 1974, and local collectors were so few that Irving Blum, a leading L.A. dealer, moved his gallery to New York. It was left to Pontus Hulten at the Stockholm Museum of Modern Art and Eddie de Wilder at the Stedelijk in Amsterdam to champion Angeleno artists in the wider world. Last year, they were saluted in a major survey, "Los Angeles, 1955–85," at the Pompidou Center in Paris.

Early years: Dennis Hopper's 1962 portrait of Robert Irwin, and artists on the steps of the Ferus Gallery, photographed by Patricia Faure in 1959.

Ed Ruscha may be the most celebrated and low-key artist now working in Venice. Born in Oklahoma, he settled in Hollywood in the late 1950s, and launched his long career of deadpan satire with images of gas stations and parking lots, before shifting to a painterly exploration of words as sign and meaning. "I lived on the other side of town when almost every artist I knew was in Venice," he says. "In 1984, I was commissioned to do large paintings for a library in Miami and needed a big workspace. That was the impetus for the move—not because I love the beach or any of those other corny things. I have a place in the desert where I go for respite."

Billy Al Bengston was born in Dodge City, Kansas, came to L.A. with his family as a teenager, and used to take the Red Car to Venice, where he met fellow surfer Ken Price. They share the studio building that Bengston has rented for forty-five years, even as he moved his home from Mexico to Hawaii to Vancouver. In the early '60s Bengston pioneered the use of industrial and spray paint techniques, while racing motorbikes for a living. Frank Gehry created a landmark installation for his 1968 Los Angeles County Museum of Art exhibition. He was acclaimed for his dazzling optical effects and—though he has moved beyond glossy metal surfaces—his latest work is full of exuberant forms and juicy colors.

Larry Bell resembles a Damon Runyon character in his battered fedora and ever-present stogie. He is best known for his glass cubes, which he describes as "three-dimensional tapestries of woven light, reflected, transmitted, and absorbed." They are fabricated in Taos, and he uses his Venice studio to make collages of thin films of aluminum and quartz in a vacuum chamber or by heat lamination in a giant press. He moved from the San Fernando Valley to Venice in 1959 and remembers it as a place for poor people where you could rent a nice apartment for $30 a month and hang out with artists in the bars. The angled facades of Market Street provide him with constant inspiration.

Ken Price is another artist who divides his time between Taos and Venice, firing his ceramic sculptures in New Mexico, and driving them to California. There, his son, Jackson, and his assistant help him paint them in as many as fourteen different colors, one coat atop another, and sand them down. There's a fusion of form, surface, and color—which seems to emerge from within as it would in a rock—and collectors cherish these intricately patterned miniatures. Price has the benign air and snowy beard of a magus. He has spent his life moving around but feels most at home in Venice, where "you can be considered a serious artist as well as a serious surfer."

Alexis Smith moved to Venice from Pasadena to work with Gehry as a model-maker, before acquiring her first studio in 1972. There she built her reputation as the maker of collages and assemblages infused with a wicked sense of humor, alternating with large site-specific artworks. "Venice used to be cheap and dangerous—a place only artists could see the beauty in," she says. "Now the demographics are getting more gray and young artists can't afford to work here." Working out of her new studio, she recently created a watercolor of the Italian Venice, overlaid with a real-estate ad for a pricey villa, a pizza slice, a handgun, and a dog turd, as a juxtaposition of romance and reality.

Ed Moses is an impassioned, energetic octogenarian, who rises at 5:30 a.m. every day to work outdoors with his assistants on several large paintings at once. He, too, was a surfer, bringing one of the first boards from Hawaii in 1939, and the spirit of the waves is felt in his joyously exuberant canvases and prints. He has created a compound on a double lot, remodeling his house hands-on, and collaborating with architect Steven Ehrlich on two wood-clad studios, the first inspired by a Pennsylvania barn. Earlier on, he befriended Gehry. "An intelligent guy, he was curious about artists so I introduced him around," Moses says. "He studied what we did and incorporated some of that in his work."

Laddie John Dill grew up in Malibu in a colony of blacklisted writers. "My mother was an artist and she took me at age seven to see a Clyfford Still," he recalls. "The realization you could put paint on canvas and get an emotional charge blew me away." As an apprentice at Gemini GEL fine-print workshop, he met the top artists from New York, and briefly lived there, before finding the first of several studios in Venice. For the past twenty-five years, he has rented a spacious loft and has worked with unconventional materials, implanting neon tubes in sand, creating relief panels of glass-covered pigment interspersed with ridged cement, and making trompe l'oeil panels of brushed aircraft aluminum.

Guy Dill, Laddie's brother, is best known for his Constructivist bronze sculptures, some intimate, others heroically scaled. These are modeled and fabricated in two lofty steel-framed sheds that he built twenty years ago. "Most artists in this area were building at some point," he says. "We didn't think of it as architecture—just something to keep out the cold, add a bathroom or a place to cook. Frank [Gehry] learned from artists adding, gutting, and exposing the structure, rather than going through a long, agonizing process of ground-up design and construction." In the early 1970s, Guy joined his brother in New York, but found it too constricting, and returned to his studio and his well-loved Mustang.

Chuck Arnoldi has moved on from his twig constructions to paint and make prints in a spacious studio he designed himself. It occupies the site of the Tasty Spuds potato chip factory, and he has a condo next door to avoid the commute home to Malibu. He had as little cash as his peers when he started out, but saw the potential in Venice and bought property when it was undervalued. "The more space the more freedom," he says. "Big lofts have an influence on what you produce. Kids have to work in garages or bedrooms—twenty feet square is a luxury. We did everyone a great disservice by discovering that lofts are wonderful places to live—most are now owned by lawyers."

Huguette Caland's father was the first president of Lebanon when that country won its freedom from French rule, and she has pursued her own independence as an artist who left her husband and children in Beirut and moved to Paris, New York, and then this raw concrete house in Venice. A mesmerizing presence in her signature caftans, she has infused the house with color and memories, painting the kitchen wall with a Byzantine-style mosaic, hanging work by artist friends, and creating her own geometrical canvases in the cavernous studio. "I love Venice," she says. "I love every minute of my life. I squeeze it like an orange and I eat the peel, because I don't want to miss a thing."

John Baldessari grew up in Southern California, has traveled widely, and won international acclaim as a conceptual artist, employing photography and language as a commentary on popular culture. Currently he's exploring noses and ears, isolating them as surreal objects. Though he's lived and worked on the edge of Venice for forty years, he stepped over the border only in 2003, creating a studio from what was once a corner grocery. Within its ivy-clad walls he has crafted a cluttered private world. "I actually don't like L.A.," he says. "I'm always slightly irritated and angry and that helps me get work done. If I were in too beautiful a place I couldn't do it."

Kim Schoenstadt grew up in Chicago, installed an exhibition of Baldessari's work as a Claremont art school project, and then accepted his offer of a job, moving from Pasadena to Santa Monica and then to Venice to be near his studio. She shares a small house with her photographer-composer husband, John, and works upstairs while waiting for the shared studio they plan to construct in the backyard. Skylights provide soft, even illumination for her meticulous pencil sketches of car wrecks, which she treats as fantastic spatial constructions. When she was invited to an art show in Poland, she turned one of these sketches into a mural, and that gave her the confidence to work on a larger scale.

Kristin Klosterman was a favorite model of Bruce Weber's and Patrick Demarchelier's while still a teenager, and she began sketching at age thirteen while attending a magnet school in West Palm Beach. She moved from Florida to Hollywood after finding New York too overwhelming and met Laddie John Dill on the Art Walk. She's been working for him since 2002, and creating her own accomplished canvases of windmills, landscapes, masks, and swimming girls, at his studio and in her apartment. "In Venice, people can be themselves," says this disconcertingly mature thirty-year-old. "As soon as I moved here, I found myself using the neighborhood, biking beside the beach, or chugging around in my little electric car."

John Okulich is another veteran, of both art and surfing, who works out of the handsome studio that Steven Ehrlich designed for him in the late '80s. The lofty space has a barrel-vaulted roof with red steel-bow trusses, and a wood-floor mezzanine overlooking the ground-floor workshop. Okulich describes himself as a recluse, who spends all his days in this commodious, light-filled volume fabricating painted wood constructions and, more recently, shallow metal reliefs that compress the energy of the early work. "This building has the raw materiality of my work," says the artist. "I added a gallery within the mezzanine; a place for contemplation amid the rafters, trying to get away from the grit below."

Lynne Hansen grew up in a small prairie town and moved to a Venice cottage in 1976 without looking back. "I loved that stark landscape, but the day I left, the wind chill factor was eighty-one below," she recalls. "Here you can go barefoot year-round, and the freedom of the place is a perfect fit for me. There's a lot of shooting and helicopters at night, but we live quite peacefully. I'm drawn to the ocean and go there at dawn to watch the sun rise and bring back creatures I find in tide pools." She paints these and does life-size charcoal portraits of fellow artists, working in a twelve-foot-square studio at the end of a luxuriant garden.

William Attaway went to Venice in 1979 because "it was the nearest thing I could find to Barbados." He rented a former gas station with a spacious yard and paints vibrant canvases in an open-sided steel shed. He used to fire large ceramic vases, but he has since moved on to colorful sculpture, incorporating materials scavenged from neighborhood alleys. He's also worked on a subway station and a rehab of the Venice boardwalk, and has seen his neighborhood transformed from a war zone where fifty people were killed in 1994. "There's less of a link between the boardwalk and the back streets than before," says Attaway, "but you can still do anything you want in Venice and dream of being the next Basquiat."

D. J. Hall lives and works in a canal-side house that was built by her architect husband, Toby Watson, in the early 1980s. The couple first moved to Venice in 1974, when their neighbor was a drug dealer, and a huge marijuana plant flourished in their backyard until the local gang stole it. Hall works like a filmmaker, hiring models for carefully photographed scenarios, which she transforms into hyperrealistic paintings of women confronting the fear of aging. But, as she explains, "light is the primary subject in my work. Its ability to evoke a sense of time, place, and memory fascinates me." Many of her compositions are staged beside pools in Palm Springs, and re-created in her sun-filled workroom.

Robert Graham has put down the deepest roots in Venice of any artist, having lived and practiced his craft on the same site, half a block from the beach, for the past thirty-five years. The Mexican-born sculptor has worked on both a monumental and a minuscule scale, in bronze and on paper, but his subject matter has remained consistent: the female figure, drawn from life. Notable exceptions include the FDR Memorial in Washington, D.C., the Duke Ellington memorial in New York, and the portal of the Cathedral of Our Lady of the Angels in downtown L.A., but everyone knows him for his nubile, anatomically exact nudes, and his success in this field has allowed him to construct a lofty studio next door to the house he built for his wife, Angelica Huston. A steel-framed wedge, tapering to a height of fifty-five feet, it's a productive workshop and his greatest monument. "Angelica's house was handmade, but the studio uses off-the-shelf materials," he says. "I wanted it to be as green as possible, so I employed solar panels, and linked it to the house with a courtyard."

Juan Carlos Munoz was one of seven youths from gang-ridden East L.A. whom Graham hired as apprentices following the L.A. riots of 1992. It was an enlightened gesture of support for talented kids, and Munoz, who had graduated from graffiti to community murals inspired by David Siqueiros and Diego Rivera, seized the opportunity. He now makes an important contribution to Graham's work, while doing his own paintings and metal sculptures in a studio nearby. "Art saved my life," says Munoz, who draws his inspiration from the ancient cultures of Mexico and the spirit of Venice, his adopted home. "When I stand beside the ocean, every wave sends a silent message that passes through my body and into my work."

Adventurous Architects

Artists paved the way for adventurous architects, besides doing a fair amount of building on their own behalf. Frank Gehry established his own office in 1962, and he recalls that the artists he hung out with in Venice gave him the confidence to express himself freely and shrug off the wounding criticism of other architects.

Some of his earliest buildings were art-related, including the studio-house of 1964–65 for graphic designer Lou Danziger and the Gemini studio of 1976–79 in West Hollywood, as well as the studio and house of 1968–72 for Ron Davis and the gallery and guesthouse of 1974–76 for collector Norton Simon, both in Malibu. The interplay of art and architecture intensified in the radical deconstruction of what he called "a dumb little house" in Santa Monica. Half shelter for his family, half assemblage, it provoked a chorus of disapproval from stuffy neighbors. In 1978, while completing this early masterpiece, he started his first Venetian project: a tower house and separate rental unit for Jane Spiller, a former employee of the Eames office.

Venice was fertile soil for Gehry's self-proclaimed cheapskate buildings throughout the 1980s, a decade that began with a series of unrealized projects and ended with his triumph in the competition to design Walt Disney Concert Hall and his Pritzker Architecture Prize. The shift from struggling outsider to international star was accomplished in a warehouse on Brooks Avenue a half block from the boardwalk. The Spiller house flaunts its corrugated metal cladding, unfinished ply, and Piranesian roof vault of tilted studs. As Gehry has said, "Everything in Venice becomes part of the context in five minutes." Spiller was closely followed by a trio of frugal live/work spaces for artists, developed on spec by Arnoldi, the Dill brothers, and Bill Norton. Dubbed the "three little pigs" by Dennis Hopper, who has incorporated them into his own compound, they remained unsold for several years, in part because the neighborhood was dangerous, and also because the site plan was accidentally flipped and the studios were oriented the wrong way.

The most fanciful and ephemeral of Gehry's Venice projects was Rebecca's

restaurant, which entrepreneur Bruce Marder commissioned for a site on Venice Boulevard across from his West Beach Café. It was a total work of art, with a forest of stripped tree trunks, skeletal glass fish, and a pair of suspended crocodiles (inspired by one that Gehry saw hanging in the city hall of Nîmes, France), plus contributions by Ed Moses, Tony Berlant, and Peter Alexander. Opened in 1985, it lasted for barely a decade, and everything but the backlit onyx walls was eventually auctioned off.

Gehry's furnishings for the Chiat/Day headquarters on Main Street were also dispersed when the agency moved to new premises in Playa Vista, but the street frontage survives intact and it remains the architect's finest contribution to the Venice streetscape. The late Jay Chiat was the Mao Zedong of advertising, believing in constant revolution. He moved his agency from downtown L.A. to eliminate any cravings for hierarchy and corner offices, providing identical workstations for himself and the most junior recruit. Later he created virtual offices in L.A. and New York, denying employees all territorial rights, and requiring them to grab any available work surface for their laptops and cell phones. The experiment was short-lived and unpopular. However, his boldest move was to commission an extraordinary building

The Spiller house (1980) is an example of Frank Gehry's "cheapskate architecture," which flaunts its corrugated metal and unfinished ply.

from Gehry, based on a sketch the architect dashed off on a paper tablecloth over lunch at 72 Market Street. (Chiat went back to retrieve it from the trash!)

Chiat/Day was located on an L-plan plot that the architect owned. In the '80s, Gehry was breaking houses and larger buildings into clusters of discrete forms to give them more presence with less bulk. Working within the thirty-foot height limit that the California Coastal Commission mandated, he designed a three-story building with a tripartite facade. To the north, a curved white-enameled screen wall evokes a cruise ship, and this horizontal sweep is complemented by the vertical thrust of splayed copper-clad beams supporting a jutting cornice to the south. Inset between is a cruciform brick structure containing the lobby and a two-story conference room above.

The central recess called for a dramatic emphasis, but Richard Serra failed to appear at a meeting the architect had arranged with Chiat. On impulse, Gehry picked up a maquette of the giant binoculars that Claes Oldenburg and Coosje van Bruggen had created for a performance piece, *Il Corso di Coltello*, on which the three friends had collaborated at the 1985 Venice Biennale, and pushed it up to his model. Chiat agreed it was an ideal fit, the artists signed on, and the sharp-edged black form now frames the entry to the parking garage. Gehry likens the swelling eyepieces to the columns of the Temple of Karnak at Luxor. The binoculars became an integral part of

Jonathan Borofsky's ballerina clown (1990) looks out to the tripartite front of Gehry's Chiat/Day offices (1991), which incorporates a giant pair of binoculars designed by Claes Oldenburg and Coosje van Bruggen.

Morphosis won international attention in 1979 for this tiny studio, which the architects called "2-4-6-8" for the yellow window frames that increase in size from two- to eight-feet square.

the architecture—in contrast to Jonathan Borofsky's ballerina clown that is pinned, like a gaudy butterfly, to the retro Venice Renaissance block up the street.

While Gehry was still struggling for recognition, another pioneering firm was responding to the gritty character of Venice. Thom Mayne and Michael Rotondi cofounded Morphosis and made their debut in 1979 with "2-4-6-8"—a studio over a garage on an alley. Yellow frames set into walls clad with asphalt tiles range from a two-foot-square window to an eight-foot-square entry portal. It has been well maintained by the original owner, Joshua Sale, who commissioned Sharon Johnston and Mark Lee, another talented partnership, to design a replacement for the house that burned down. Its cool, gray volumes play off the searing yellow frames of the studio. Sadly, 72 Market Street, the wonderfully complex, trend-setting restaurant commissioned from Morphosis in 1987 by a group that included Tony Bill, Dudley Moore, and Liza Minnelli, was sold and stripped by a later owner.

A third architect, Frederick Fisher, apprenticed to Gehry for two years, and brought his love of art to a wide range of understated buildings. Having grown up on the shores of Lake Erie, he felt unsettled by the huge sprawl of L.A. and moved to Venice in 1977 to be close to the ocean. "That provides a finite edge, and there's only half a city to deal with," he says. "After having a knife held to my throat while living on East Fourth Street in New York, Venice was a picnic by comparison, and its density put everything within easy reach."

Fisher launched his practice in 1980 with a house near his own for composer Loren Caplin and his artist wife, Anne-Laure, which seeded the architect's work for the next decade. She had lived on a boat on the Seine and that inspired the wooden hull of the roof. The couple wanted separate studios, which open onto a soaring central atrium. The rough-edged aesthetic betrays the influence of Gehry and the Japanese concept of *wabi-sabi*, which prizes the imperfect and incomplete. It is also the expression of a cultural phenomenon. The Caplins were closely involved in producing *Wet*, the short-lived "magazine of gourmet bathing" and voice of bohemia, which explored relationships among the arts, fashion, cooking, and bodily pleasures.

The Caplin house has a distinctive profile, but it fits in well with its generic neighbors. That's the challenge that every architect confronts in this tight-knit, modestly scaled community. Most of the lots are thirty by ninety-five feet with a thirty-foot height limit and mandatory setbacks at the front and sides. That makes it hard to satisfy contemporary demands for more space while achieving a mixture of openness and privacy and a balance of light throughout a three-level interior. The challenge is all the greater on the walk streets, canals, and beachfront, where constraints and expectations are most extreme.

Walk Streets

Narrow walkways extend for several blocks to the west of Lincoln Boulevard and shorter pedestrian lanes link Pacific Avenue to Ocean Front Walk. Their village scale is enhanced by mature trees and leafy front yards with picket fences. Service roads alternate with walk streets to provide rear access for cars and deliveries. The charm of these rustic enclaves is being eroded as bungalows give way to inexpressive boxes, and the fences go higher than the regulations allow. A few architects have responded in a sensitive and inventive way, turning the constraints to advantage.

1 Japanese Intensity

The house-studio that Fisher built for Ken and Sandy Bleifer in 1992 is located a few doors from the beach. He is a physician, who needed a small office and a cellar for his prized wine collection; she is an artist who works with *washi* to create collages and trunks with peeling bark. To meet these needs on a narrow, tightly confined site, the architect placed a lofty studio over the garage on the service road, and turned the Caplin atrium into a Japanese-style inner courtyard. This separates the studio from the house, which opens onto the walk street across a vestigial front yard. By building to the edges of the lot, Fisher has achieved a sense of compression that is released when you step within. The sun-bleached aggregate concrete blocks of the central bay retain their vibrant red tone in the open living area, and complement the hardwood floor, white plaster walls, maple and cherry cabinets, and exposed fir joists. A glass trapdoor in the floor of the living room allows wine to be hoisted up in a basket from the cellar. A tilted soffit on one side suggests a boat—in a nod to the Caplins and the ocean. The kitchen is tucked in below a mezzanine gallery extending forward to the master bedroom and back to a steel bridge that provides upper-level access to the studio. As in all this architect's work, there's warmth, humanity, and a feeling of handcraftsmanship that softens the abstract geometry.

Venice, CA — Walk Streets

2 Playful Simplicity

Hank Koning and Julie Eizenberg, a husband-wife partnership from Melbourne, Australia, design frugal housing and public buildings that are simple, relaxed, and green. They've lived and practiced together in Santa Monica since 1981, but they are still intensely Australian in their directness and hatred of pretension. In Venice they designed a row of artist workspaces on Electric Avenue, and produced an imaginative, though hotly contested redevelopment plan for the Metropolitan Transit Authority bus yard on Main Street at Rose. "There's a lot of architecture that spends time telling you how clever it is," says Eizenberg. "Not finishing is a way of letting go. What's important is space and how the light strikes, not the perfect detail."

The 1998 Michael and Judy Israel house embodies that philosophy. It's on a walk street a few blocks up from the Bleifers', but the owners—he's a psychoanalyst, she does photography—split three lots with another buyer and that gave them an extra fifteen feet for a side yard. The architects have taken advantage of this by creating a linear house on two levels, set back from the street and extending along the east side of the lot. The street facade is faced in hardy board and flared below a gable to evoke a period cottage, playing off the vintage apartment building and mature eucalyptus trees across the street. There's no sense of pastiche: the upstairs windows are asymmetrical; the one below is screened with battens. The ground-floor living areas open to the front and side yards, which are treated like outdoor rooms.

Playful touches enliven the simple volume. Three treads of the staircase project through a corner of the kitchen ceiling. Green closet doors open to reveal a scarlet-lined bar as though you were slicing a watermelon. The upstairs ceiling has a gentle pitch and is clad in pale Philippine mahogany, which is cut away to reveal the trusses in a study extending out of the corridor linking guest and master bedrooms. Sliding doors, flaps, and casement windows open to provide cross ventilation—no need for air-conditioning so close to the ocean—and a balcony juts from the master bedroom over the side yard. In contrast to the impassive block on the neighboring lot, this is an expansive, joyous house.

36 Venice, CA Walk Streets

Canal Houses

A grid of two long and four cross canals survive from the foundation of Venice, though these were constructed independently of Kinney's network. Restored and upgraded in 1992, this is an improbably bucolic enclave for pedestrians and the occasional small boat, where only ducks are noisy and cars are banished to rear alleys. Hump-backed bridges link the footpaths at the water's edge. The canals are lined with about 350 houses in a cheerful confusion of styles, from tiny clapboard cottages and pompous Cape Cods to developer boxes and a scatter of uncompromisingly modern dwellings by progressive architects.

Outsiders are few and residents look out for one another, sometimes leaving their doors open to unfenced front yards. A new arrival calls this "a village within a village; unique but not precious." Christmas is celebrated with an appealingly disorganized parade of boats, which gives locals a chance to indulge their fantasies of dressing up or making a protest, but they betray a lack of seamanship that would shock a true Venetian. Many boats fail to complete the course, but the spectators are too amused or inebriated to care.

1 Colorful Transparency

"Venice is polyglot and tolerant; a creative environment with people who are open to new ideas," says L.A.-born architect Glen Irani. He has designed six houses on the canals since 1996, living in three of them. The first was a bachelor pad, the second worked well as a living space for him and his French-Canadian wife, Edith Beaucage, who is an artist. The third, completed in 2004, also accommodates her studio, his office, and their small son. The rigor and transparency of his architecture, inspired by his training in the offices of Richard Meier and Skidmore, Owings & Merrill, has been infused by her passion for color and sensuous shapes. "It's a laboratory," says Irani, "a prototype for a three-story house that achieves lightness by appearing to hover above the ground." He achieved this illusion by cutting away the lower story to accommodate a lap pool, which runs parallel to a sunken drafting room with glass sliders and four workstations.

The house stands out from its neighbors in its bold planes of orange and blue, the transparency of the facade, and the clear and translucent "clouds" printed onto the glass. The high fence was required to protect the pool—the owners have no concern about people looking in—and they have created a starry sky of inset ceiling lights in the living room. A path of circular pavers set in river rocks leads up to the entry on the blank east side. Steps descend to the office at the front and an airy cable-suspended staircase leads up to the open living area on the second floor, with its radiant-heated concrete floor and sleek built-ins. Color is used as exuberantly here as on the facade: chartreuse for the staircase, a sky blue wall upstairs, and a scarlet ceiling in the third-floor master bedroom. Rooms open up to balconies overlooking the canals and to a grassy terrace hollowed out of the west side to meet the code on setbacks. Here, as in his previous house, Irani has used biomorphic shapes to inflect the box and to squeeze and expand the space. "Once you master the constraints, you can break free—like Houdini," he says.

42 Venice, CA Canal Houses

43

2 Material Invention

The tight-knit complex that architect Whitney Sander built for himself and his wife, Catherine Hollis, is packed with inventive ideas, but they all grew out of three cubes—two stacked to form a house, and one raised above a carport to serve as a studio. "I have great faith in simplicity—the complexity will follow," says Sander, who worked within a footprint only twenty-two feet wide, three of which are taken by a set-back entry and a stairway to the roof. "The narrowness made it tighter and more elegant," the architect says. "The two volumes play off each other and provide a sequence of experiences you wouldn't get in one block." Horizontal steel louvers shade the translucent Cyro plastic walls of the studio, and vertical louvers do the same job for the south side of the house, fanning out on the canal side to draw in ocean breezes. Cladding board to the north and east is protected by perforated aluminum, which catches the light and reduces the bulk of the block. The entry is emphasized by a bold accent of red, and the house opens up to the canal through a wall of glass. An unfenced expanse of rounded pebbles, enlivened with papyrus and two ornamental rocks, deters cats and ducks from walking into the house.

Within, a central atrium rises twenty-five feet from a glossy walnut-stained concrete floor to a gray-tinted skylight. The ground floor is divided into kitchen, dining, and sitting zones. Parachute nylon drapes can be drawn around the living area, providing privacy and an element of shade. They soften the folded half-inch steel of the stair treads, fireplace, and mantel, and the braced steel columns that support the upper floor. Upstairs, the surfaces are softer: a floor of bamboo steps up from the office to the bedroom and folds up to form a parapet overlooking the canal. Hard and soft surfaces, sensuous curves and sharp angles play off each other to enrich the house. Solid elements dissolve in light, most strikingly in the bands of acrylic that surround the central void.

47

3 **Floating Geometries**

"Creative people need to have a space in which they can daydream," says Shelley Berger, who left the practice of law to write poetry. "As Anaïs Nin wrote in her diary, 'I couldn't live in the world of my parents so I had to invent my own.'" She and her husband, artist Lothar Schmitz, acquired one of the last empty sites on the canals from the son of an Italian immigrant who bought four plots from Abbot Kinney in 1920, intending to pass them along to his children. Berger and Schmitz chose architect Michele Saee for his willingness to experiment on a low budget. They specified a few basic requirements and gave him a free hand.

An oiled plywood box with narrow side openings and a glazed front tilts down over the white stucco living area, which opens onto the front yard through a wall of glass. An exposed steel frame supports the upper story on two upright and two tilted columns and there's an interplay of geometries at the point of intersection. The tilted window reflects the canal and draws the eye down from the master bedroom. Saee's goal was to make the spare interiors, accented with orange acrylic, feel as though they were floating. Berger has a tiny sliver of space as her office looking onto the canal and Schmitz's studio is in back, over the garage. "It's less a house than a casing for space and light that reaches out to nature," she says. "The architecture invites attention, and we sometimes feel we're in a goldfish bowl with tourists lined up to snap." The roof terrace offers a refuge, and the drought-resistant yard will soon be enclosed with a translucent fence and palisades of bamboo.

49

4 **Incremental Improvements**

Mark Mack and his wife, Faiza al-Hassoun, who is Egyptian, moved to Venice in 1991 from San Francisco, which she considered too cold. "In Cairo, I dreamed of living by the Nile," she said, "so when we found this little cottage by the water, my heart leapt." Mack's practice keeps him busy and, though his office is located on a neighboring canal, he began to upgrade his generic box at a very leisurely pace. Twelve years on, there's still a floor or two to resurface and the architect confesses that the lack of completeness doesn't bother him as it would a client.

The core of the old house is sheathed in wood and stuccoed in Mack's favorite earthy hues. The living room opens through sliders to an unfenced front yard. Stained maple cabinets arranged like *tansu* chests form a staircase, which leads up to a new master bedroom at the front. In back, over the garage is a duplex apartment for their grown son. Having lived for years with dangling wires and the prospect of more construction, al-Hassoun now feels at home. "On a fine day, the canals are constantly changing color," she says. "We face south, and when the sun hits the water it reflects a dancing pattern of ripples onto the ceiling."

51

Oceanfront Living

Constraints on oceanfront properties are similar to those on the canals: narrow lots, a service road to the rear, and the boardwalk in front, but the view is infinite, and a wide expanse of sand separates the houses from the water. Even the crowds tail off to the north and south of the commercial zone, leaving the residents to enjoy their idyll undisturbed.

1 Lifeguard Redux

Bill Norton, a writer-turned-director, asked Frank Gehry to transform a humble beach-front cottage into a family house. A junior lifeguard at age twelve, Norton has spent much of his life on Venice Beach—surfing, kayaking, and scuba diving. In the 1960s, when he graduated from the UCLA Film School and settled there, his neighbors included Jim Morrison of the Doors (who composed "Moonlight Drive" on Venice Beach), cinematographer Carroll Ballard, and other fledgling cineasts. He directed *Cisco Pike* on locations that he walked by every day.

To save money, Gehry kept most of the old bungalow, and added two stories and a stepped roof deck to the rear. Small living spaces are cunningly interwoven on different levels, and the hearth in the third-floor master bedroom projects into a double-height glass bay to the south. A log *torii* serves as a symbolic gate and reminds Norton's wife, Lynn, of her Japanese roots. A study propped on a post balances the new rooms at the front of the site and mimics the lifeguard station just beyond. The original materials of the study succumbed to the salt air, but the retreat has been sensitively re-created, with plywood flaps and inner walls. From here, as from the terrace over the original cottage, you feel you are hovering over the beach, and the study is used more often for drinks at sunset than poring over a laptop.

2 Light-filled Aerie

In 1990, the Albuquerque-based architect Antoine Predock had an office on Abbot Kinney Boulevard, and he designed this beach house as a light-filled loft. Translucent glass along the south side gives the split-level interior a warm glow. Three windows are set at different depths within a powerful concrete frame that stands right up to the boardwalk, and one of these is a huge expanse of glass set into a pivoting red frame. Below this window, water flows over a block of black granite, joining the ocean to the sky and bouncing light into the living room. The whole house was designed as a bachelor pad, and when Eric and Nancy Saarinen moved here in 1996, they commissioned David Hertz to enhance and soften Predock's austere living room. Eric Saarinen is the son and grandson of legendary architects but was inspired by his godfather, Charles Eames, to make his career as a filmmaker and cinematographer. His wife, Nancy, is Austrian, paints naturalistic portraits, and likes warmth and clutter.

Hertz replaced a wedge of polished granite that forced the perspective from entry to window with a maple floor, and used Syndecrete for the counter and work surfaces of the open kitchen. Left unchanged are the subtle folds in the ceiling and the shifts of height. A hearth projecting out at an angle articulates a living area overlooking the beach. The owners entertain friends to dinner around a prototype wood-topped oval dining table in the central bay, and the kitchen is tucked under a mezzanine office. Steps at front and back lead up to the master suite, which opens out through concertina wood-framed glass doors to a tiled deck and back up to the stepped roof—an amphitheater looking out to the ocean. "This is the best hotel in the world," says the owner. "I love the diverse mix and art of Venice; you can feel the pulse."

3 Panel Game

Surfers riding the waves to the north of the Venice fishing pier have the best view of the house that Thomas Ennis commissioned for his family, and thus it's familiar territory for the architect David Hertz. Two steel-framed stories rise from a concrete base containing an expansive garage, storage, and services. Aluminum-faced refrigeration panels are clipped to the frame to form a curtain wall that alternates with sheets of translucent and clear glass. These are notched and angled on the long south wall to pull in natural light and frame ocean views, and the floor-to-ceiling glass wall of the mid-level living room cranks down to form a waist-high parapet. The geometry of steel and concrete, aluminum and glass, and the cantilevered balconies recall the asymmetrical compositions of R. M. Schindler, the Austrian-turned-Angeleno, who drew inspiration from the De Stijl school of Dutch modernists.

The owner makes equipment for car washes, and the house is full of water features, from the fountain splashing over mosaic at the front to an automated shower for people coming off the beach to a swim-in-place pool on the roof deck. The architect has used renewable walnut for stair treads and the angled kitchen cabinets, playing this off concrete floors, exposed steel joists, and decking. A pneumatic glass elevator rises from garage to roof. It's a tough, practical, energy-efficient house that draws its power from photovoltaic panels on the flat roof, and is naturally ventilated. The insulation panels would keep ice frozen in the desert, and they have a forty-year guarantee against the corrosive salt air. The house that formerly occupied the site had none of these assets, but it was briefly home to Jim Morrison, and Hertz was careful to save all the doors.

Looking Inward

Narrow lots can be enclosed and houses pulled apart to open up to interior courtyards and outdoor living spaces that are private and protected. It's a way of living that flourishes in Asia, Africa, and the Middle East. The Moors brought the concept to Spain, from where it spread to Latin America. In Venice it's employed—as contemporary Japanese architects are fond of doing—in response to the tight urban grain.

1 Pointing Skyward

Like Antoine Predock, the Austrian architect Wolf Prix was another outsider who understood the spirit of place, but both men chose the wrong time—the early '90s recession—to set up offices in L.A. As co-founder of Coop Himmelb(l)au (blue-sky cooperative), Prix had ambitious plans to build in L.A., but was able to realize only a modestly sized spec house before returning to Vienna and a meteoric rise in his fortunes. His firm later won a competition to design the Performing and Visual Arts Academy downtown.

Using the torqued geometries and folded planes that are the firm's signature, the architects created a three-level duplex. The two steel-framed towers were clad in corrugated steel and cement board and linked by an upper-level bridge. The front tower has a Z-profile; the rear unit has an inset trapezoidal turret at the upper level. Completed in 1999, it stayed on the market for three years before Virginia Moede, an interior designer, moved there from Malibu. "At first I didn't get it, but then I realized it's a vertical house aimed at the sky," she says, "and I call it Himmelhaus."

Determined to keep the quirky, sharp-edged geometry but make the house more habitable, Moede turned to Michael Hricak, an architect with whom she had studied. Much of the work was done by contractor Roland Tso, a Yale School of Architecture graduate. New walls of graphite steel-troweled plaster were inserted to link the two structures at ground level, and the solid skin was opened up to the fenced, hardscaped yard. Steel stairs slice through the void of the front lobby. Above is a mezzanine gallery and, above that, a media room with a flat-screen television set into bonderized plywood paneling around the stairs. These continue up to a diamond-plan roof deck with a grouping of four plastic Philippe Starck club chairs. The new link of stucco and translucent glass leads back to the dining room and kitchen, which occupy the former garage, and the master bedroom above. The turret serves as a guest room. At each level there's a wonderful interplay of angled walls and glass, and tightly framed vistas over roofs. Moede sold all her old furniture to start with a tabula rasa, and has chosen for now to live beneath open wood trusses with a bare minimum of possessions.

Venice, CA Looking Inward

2 Soulful Simplicity

Michael and Susan Rosen moved from Philadelphia to California to be near the Pacific Ocean, and after living in Malibu, looked for a place that was more eclectic in feeling—like the neighborhoods they grew up in. They are consumed by design—he's in the garment business and values handcraftsmanship and she has a design practice—so they commissioned a pure, rigorous house from architectural designer Charles Ward. He stripped a three-unit apartment to its bones and reskinned it with earth-toned, steel-troweled stucco. It's set back behind a solid wall to provide a feeling of security in a tough neighborhood, and Jay Griffith's landscaping of cottonwoods and wild grasses evokes New Mexico.

The interior has a soulful simplicity, employing a few expressive materials punched up by Scarpa–esque steel fittings. Ward kept the delicate wooden trusses of the shallow-pitched ceiling, and elevated the walnut floor of the open kitchen to serve as a bench rising from the concrete floor of the living and dining areas. The two-story volume at the center of the house and a mezzanine bridge that leads from front to back contrast with intimate private rooms. The house picks up natural light in interesting ways—shimmering through molded glass and splashing off concrete floors. Everything is subtly layered, with small steel-framed windows set into a wall of glass to provide ventilation and, in the bathroom, mirrors framed by translucent glass. "Everything but the appliances was built on-site, so that there will never be another house just like this," says Michael. "It's new but also old; nothing is shiny or painted. Charles is an artist who likes to stand back before he finishes; it's essential to be patient."

The rigor extends to the artwork and idiosyncratic furnishings such as a massive steel cart used as a coffee table. "The house is not about furniture, and we are reluctant to bring in a special piece unless we have somewhere to put it," says Susan.

Venice, CA Looking Inward

75

3 Work in Progress

In contrast to the precision and order of the Rosen house, Dennis and Victoria Hopper inhabit a work in progress. It expresses the character of a man who has always lived on the edge. At age eighteen, Hopper moved to L.A. from Kansas to act with James Dean in *Rebel Without a Cause* and *Giant*. "In 1954 Venice was a slum, but it was the only place in L.A. where you could walk—if you didn't mind being mugged," he recalls. From the start he was drawn to the bohemian life, hanging out with artists and Beat poets. Andy Warhol had his first show of soup cans at the Ferus Gallery in 1964, and Hopper had a bit role in *Tarzan and Jane Regained... Sort Of*, a silent movie that the artist made on location in the Venice canals by turning on a camera and allowing everyone to improvise.

Hopper's triumph as director and costar of *Easy Rider* in 1969 was forgotten as his life and career spun out of control. Act two began in 1985, when he emerged from rehab in New Mexico, and settled in Venice. He bought one of Gehry's "three little pigs" (which no one else wanted), but the architect was too busy to make the needed improvements and recommended Brian Murphy, a design/build maverick. That was the beginning of a productive collaboration that now encompasses all three of the pigs, a main house next door, and a lap pool and refurbished cottage on the lot beyond. "Everything grew incrementally," Hopper says. "Brian has incredible imagination and picks up on all my ideas."

Colors, a harrowing 1988 feature on gang warfare that Hopper directed, gave him the confidence and resources to start building. "Producer Mike Medavoy asked me if there were any gangs in L.A., and I replied, 'Yes, right in my alley.'" It's generally assumed that the fortress character of the house with its angled planes of corrugated metal and razor wire in back (softened by a recycled white picket fence) is a response to the frequent shootings, but Murphy insists that the program was driven by Hopper's passion for collecting art and his need to maximize hanging space. Marriage and children have brought many changes behind the facade. An auto court was built over (though a tree still grows there) and family rooms were added above. A fully equipped theater in front was rarely used and was converted into a workroom. It's easy to get lost in the labyrinth of rooms and bridges but that adds another level of adventure to a house that defies all conventions.

Every surface is covered with art—mostly by the owner's many friends. But Hopper himself has done some large-scale photo-realist paintings in addition to the photography for which he is best known. There are assemblages by George Herms, huge canvases by Chuck Arnoldi and Laddie John Dill, a tiny Sam Francis from his days in Paris, a collage that fellow actor Dean Stockwell did in Taos, and hundreds more. The house itself is a rough-edged work of art: exposed studs, demountable walls, laminated sandwiches of broken glass in a stair landing, on kitchen cabinets, and, most disturbingly, an apparently splintered glass bathtub designed by Simon Maltby. There are wonderful shifts of perspective from one space to another and out through angled windows to palm trees and chain-link fences. "The gangs know where I live but so far they haven't bothered me—though they've taken the back gate off its hinges to let me know they are there," says Hopper. "I heard one guy going by and telling his friends: 'He's a crazy man, an OG [old gangster]. You want to live in a prison like that?'" Behind the wall, the OG is at peace, savoring his cigar beside the pool in a setting as rustic as it must have been in the 1920s.

79

4 Open to Nature

Architect Steven Ehrlich lives on a quieter street, and the wall he wrapped around the corner site is a translucent membrane of white acrylic/fiberglass that catches the shadows of passersby and glows from within at night. The two-story house exploits the linearity of the site, opening up on three sides through sixteen-foot-high glass sliders to a huge branching pine on the west side, an entry court/pool to the south, and a garden court to the east. There's a seamless link between indoors and out, concrete floor and hardscape. Outriggers over the pool support motorized red blinds that block the sun and provide another screen for the play of shadows. At the end of the site is a detached studio/guesthouse. The steel beams (with chalk and weather marks) are exposed, and the three open sides are clad with rusted Cor-ten, backing up to a northern boundary wall of bead-blasted concrete block.

"Venice is gritty and unpretentious and the house expresses that," says Ehrlich, who discovered the advantages of courtyard living during his years in Morocco as a Peace Corps volunteer and, later, as an architect in Niger. "It's nice to be in a compound where you are open to the elements while enjoying privacy. Walk outside and you are part of a vibrant community." This is Ehrlich's eighth house in Venice, and each has been a laboratory for living on tightly confined sites.

Muscular and raw, this house is softened by the presence of nature and the refinement of the gypsum plaster and Finn-ply cabinetry. Ehrlich shares it with his wife, journalist Nancy Griffin, and his three grown daughters sometimes sleep over in low-ceilinged pods suspended within the central void. There are other intimate hideaways, but the central stairs, art, and eclectic furnishings seem to float within an airy, light-filled volume. From every point, you are looking through and out, making this a minimal shelter with a maximum of emotional resonance.

85

5 Minimal Loft

The same simplicity, tough finishes, and generosity of proportion are found in a row of four identical lofts that Ehrlich designed for a through-block site near the beach. ICM agent David Unger bought one and recommended two others to friends in the movie business. "Architecture was the draw," says Unger. "I was a bachelor then and when I saw this, I passed on the house in Coldwater Canyon I was bidding on." It seems to work just as well for his wife, Melissa. Their spare furnishings set off the soaring volume and the brilliant light that filters in from above.

6 **Sensuous Laboratory**

Like Ehrlich, David Hertz has built all over Venice. Inspired by memories of Bali and its breezy, open-sided houses, he recently added a kind of lanai to the innovative family house he completed twelve years ago. Occupying the adjoining lot, the addition anticipates the needs of three growing children and the possibility of bringing his practice home.

"I enjoy being outdoors more than in, and nature was my guide in designing this shelter," says Hertz. "It was conceived as a laboratory where I could experiment on myself before trying out ideas for energy conservation on my clients." The house and the addition push to the outer edges of the double lot, enclosing inner courtyards. Bridges link the second-floor spaces, and there's a lap pool between. It feels more like a village than a house—and it can accommodate a village: fifteen hundred people crowded in for a fashion show staged on a runway over the pool. The boundaries are blurred by fences and stands of bamboo that shut out the neighbors. A sunscreen of wooden slats and pocketing glass sliders in the ground-floor rooms of the addition evoke the airy, open structures of South Pacific islands.

Though the original house was conceived and completed in a year on a tight budget, every part of it was carefully designed to respond to the path of the sun, the prevailing breezes, and the alternation between warm days and cool, foggy nights. "The house doesn't scream, 'Look at me, how efficient I am!'" says Hertz. "You have to experience that." He created a multilevel complex of interlocking volumes and open terraces that's half cave, half tree house, and is an adventure playground for the children. Their mother, Stacy Fong, has an open-sided mezzanine office that doubles as a command post. The new house occupies a similar footprint, but is much looser in spirit. As the sunlight streams in, and you feel the breeze off the ocean, it's easy to imagine you're on a tropical island.

91

7 All That Jazz

Another versatile architect, Lorcan O'Herlihy, built a steel-framed tower house for himself and his wife, the actress Cornelia Hayes, on a vestigial plot of flat land jammed up against a busy street. It replaces a shack one-quarter the size that the couple bought and lived in for five years because they loved the location (a block from the ocean), and the free-spirited character of the neighborhood. The product of his inventiveness is rigorous, roomy, frugal, and eye-catching: a major step forward for a burgeoning practice.

The structure is concealed by its skin: an elongated grid of charcoal cement boards accented with blue and green panels, as well as clear and colored glass. O'Herlihy is a painter as well as an architect, and his geometric collage is infused with jazz rhythms in the manner of Mondrian's *Broadway Boogie Woogie*. The ground floor is cut away for a double carport with a studio to the rear; the second floor contains the master and guest bedrooms; the third, a living room to the rear and a kitchen-dining area in front. These spaces form a racetrack around a central stair that rises to a glass-walled pavilion on the roof terrace, which serves as an outdoor room with an ocean view for entertaining or as a quiet retreat. O'Herlihy designed most of the furniture, and his beds, wood-framed sofas, and cabinetry are perfectly scaled to the rooms to achieve a spare informality.

There's a sharp contrast between the flush outer skin and the deep relief of the interiors. Walls and ceilings are cut away to accommodate the glass and recessed lighting. The ninety-six small openings provide cross ventilation and frame pieces of neighboring buildings, trees, and the street below, creating living artworks to complement paintings hung in the spaces between. By day they admit shafts of differently toned light from the pale blue, green, yellow, and clear glass that animates the rooms; at night, there are fugitive gleams from street lamps and neighbors' windows. There's a sense of being inside a magical box that has fragmented and reordered the outside world.

8 Concealed Openings

Stephan Mundwiler grew up in Switzerland, and he created this precisely detailed chalet for escrow officer Brenda Bergman to replace a 1950s stucco cottage in which she had lived for thirty years. He calls it the Coconut House for its hard shell and soft white interior, and everything about it says "home." From the street it appears as archetypal as a Monopoly house: a narrow, two-story block with a pitched roof, tightly skinned with dark brown Prodema (a phenolic resin wood-veneered board). There's a picture window at one corner of the ground floor, but the wall above is blank. One side is cut away to create an entryway, and the rooms at front and back open onto a central patio, which is pulled out from the line of the house like an open drawer below a raised screen wall of aluminum louvers. The living area and kitchen-dining flow out through concertina glass doors into this outdoor room. The iron-wood deck continues the flow of the walnut boards inside. Translucent glass screens the staircase that leads up to a spacious glass-walled bathroom. The master bedroom at the front is lit from the patio, with opening windows for ventilation and no need of blinds. The impassive facade masks a house that is entirely open and transparent, its crisp finishes dappled with sunlight.

Additions and Remodels

The typical Venice house is a pocket-size clapboard or stucco bungalow on a thirty-by-ninety-foot lot. As site values climb to $1 million and more, these cottages, which define the modest and intimate character of the community, are being torn down and replaced. A few architects have found ways of extending their lives by remodeling and adding to the original structures, and a similar strategy is saving some of the old warehouses.

1 Green Showcase

Frugality and sustainability are the hallmarks of Pugh + Scarpa's varied practice, and the house that Lawrence Scarpa and Angela Brooks built for their family showcases those principles. Despite its imposing facade, it is actually an addition: a spacious living area grafted onto the rear of a vintage six-hundred-square-foot bungalow, and an upstairs master suite that is cantilevered back without touching the roof of the old building—thus avoiding a requirement to bring the old structure up to code. A tilt-up concrete shear wall braces a wood-frame structure, and a steel frame supports the cantilever.

Ninety solar panels wrap the south side and canopy the bedroom terrace, blocking the sun and generating an energy credit. The house is cooled by cross ventilation, and all rainwater is retained on-site. A narrow, wedge-shaped lantern rises above the kitchen, pulling in natural light and doubling as a heat chimney when the skylight is opened. Pocketing glass sliders open the living room to the front yard, and the master bedroom leads out to a terrace, eliding the boundary between indoors and outdoors. "I grew up in Florida, where it is miserably hot and humid, and you get sweaty walking from your house to the car," Scarpa says. "The ocean breezes in Venice make this the best climate on the planet, and it's a crime not to take advantage of it."

From the front you can look through the house to the street on the far side, and glimpse treetops through the glass in the bedroom. Openness and transparency dematerialize the gritty steel and concrete, and a *brise soleil* of bristles filters the light. Scarpa, who ordered this novel feature from the manufacturer, calls it the world's largest scrubbing brush. Leaves from a eucalyptus that the architect planted five years before and had to sacrifice for the addition were laid in the concrete forms and pattern the surface of the wall beside the entry. A low wall that surrounds the plunge pool also serves as a bench for entertaining, as does the edge of the sunken living room.

Almost everything in this inventive house is multiuse or is made of recycled materials. The entry to a guest bathroom is concealed behind a hinged section of the bookcase that lines one wall. Concrete steps with a cantilevered handrail lead to a springy mesh staircase supported on a steel tube of the same rusted steel, which runs up the inner wall, hovering over a massive built-in sofa. The interior is a collage of textures and tones, from the patinated steel panels around the hearth to the soft suede finish of Homosote (pulped newsprint) on the walls.

Venice, CA Additions and Remodels

2 Frugal Artistry

The plywood box that architect Barton Myers attached to the rear of a modest bungalow is a frugal, woodsy version of the soaring steel and glass house he designed for himself in Montecito. Noreen Morioka, a partner in the design firm of AdamsMorioka, is a friend and she invited him to do this lovingly crafted master suite for her and her partner, chef Shari Lynn Robins. Sweat equity and scavenged materials kept the cost down, but there's more artistry here than in most million-dollar homes. The rough-textured exterior is stained in tones of red, green, and brown, which have already acquired a soft patina.

Old and new are separated by a cross-axial breezeway leading out to the yard through glass doors at either end and lit from the glass roof. A wall of boldly grained cedar ply frames a closet-lined corridor that leads into the loftlike bed sitting room. The same marine-grade ply wraps the room on three sides, and the entire south wall is composed of pocketing sliders and a roll-up glass door that open onto the landscaped courtyard. A bathroom with a Japanese soaking tub opens into the room and the yard, and there are other Asian references in the watery grain of the inner walls, the meticulous floor cabinets of dark brown Finn-ply crafted by Takuhiro Shinomoto, the Japanese scroll over the bed, and the Pakistani rug on the concrete floor. The spare space, furnished with Eames classics, reminds Morioka of her heritage as a third-generation Japanese-American and of the humanity that infuses Myers's work.

3 Trailer Treasure

David Hockney would love the surreal juxtapositions that architect Jennifer Siegel has created around her bungalow. The plain white stucco street facade is swallowed up by the sculptural forms of dwarf red banana trees and other exotics, and a commercial freight trailer is hooked to the rear to be used for yoga or as a second bedroom. The contrast between this blunt steel container and the delicate line of red tiles atop the white stucco walls is intensified by the presence of a blue-tiled spa, and a towering palm and big satellite dish in the neighbor's yard. "Venice is a small town of tinkerers, and it's productive," says Siegel. "I grew up back East where problems are kept in your head and thought about until they're solved. Here, they're something you work on with your hands, as did the Eameses and Gehry."

As head of the Office of Mobile Design, Siegel builds for people who like to live light. "I spent a few years during high school in Israel on a kibbutz and traveling with a Bedouin," she says. "I'm a nomad and I'm comfortable with new situations." Working out of Eric Orr's former studio, she has explored mobile structures that have led to the design of the 720-square-foot Portable House, and larger variations, all of which can be fabricated as steel-framed modules in a fully automated factory and extensively customized. Twelve of these are in development, and Siegel installed a show model on Abbot Kinney, north of Venice Boulevard (page 113, top).

112 Venice, CA Additions and Remodels

113

4 **Spatial Illusions**

Steven Shortridge, a partner in Callas Shortridge Architects and a protégé of the late Franklin Israel, remodeled a 750-square-foot bungalow for himself, creating the illusion of space by weaving the tiny rooms together, warming the stucco with intense colors, and opening the house up to a yard fenced with cement panels and translucent fiberglass. The original two-room cottage was moved to this empty lot in 1937 and was decrepit when the architect found it in 1998. Jay Griffith, who planted the yard with bamboo and palms, peppers and plums, likened it to "a little house in a terrarium."

The house is also enriched by the dialogue of old and new. Shortridge retained the existing walls but refaced them in steel-troweled orange stucco, stripped the pine window frames and oak floorboards, and inserted three windows in place of the original entry on the north side. A laundry has been added as a saddlebag on the back side. A steel and glass canopy marks the new entry to the south. From here you step into the tiny kitchen and a snug living and dining room with a raised ceiling of straight-grain Douglas fir. The architect customized an L-plan Vladimir Kagan sofa, and added bookshelves and a Saarinen Tulip Table for dining. The second room is divided between a compact office and a sleeping area on the opposite side of the desk and cabinets.

116　Venice, CA　　　Additions and Remodels

5 Big Lift

Bernardo Charca, an Argentine-born architect, raised a bungalow on hydraulic jacks and inserted an open-plan live/work space below for himself and his wife. It's a poetic metaphor for the life of this poor immigrant, who moved to East L.A. with little education and no resources, attended the Southern California Institute of Architecture, and launched a design/build practice. He struggled for work during the early 1990s recession and supported himself doing entertainment design (including the fun house for *Toy Story*). Searching for affordable space in which to live and work, he realized that it made more sense, structurally, to insert a story below than to add a second on top. A steel-troweled stucco skin creates a seamless link between old and new, and steps lead up to a second-floor rental apartment.

A fence of Trex (plastic recycled lumber) strips woven like basketry around steel poles encloses the front yard, and this is replicated in the rail around the deck that extends from three sides of the second floor. The fourth side of the ground floor is pushed out three feet to the east and is lit from a linear skylight. The deck shades the glass sliders that open onto a south-facing yard, and windows to the west from summer sun, while allowing it to penetrate and warm the concrete floor in winter. The new space is entirely open, with radiant-heated floors and exposed glulam beams that support the upper story. Storage and office spaces flank a curtained bed, and an open kitchen is located under the skylight. The massive wooden dining table at the center of the room and the circular marble-topped Saarinen table were both scavenged, making this a showcase of frugal living. Since this house was completed, a second bungalow has been raised and a third project has been permitted.

120　Venice, CA　　　Additions and Remodels

6 Playing the Angles

Austin Kelly worked with the radical architect Eric Owen Moss and Monika Haefelfinger for Herzog & de Meuron in Basel, before Kelly and Haefelfinger opened their office, X-Ten, in downtown L.A. Their different sensibilities are fused in the cottage they remodeled and extended for a young couple on the southern border of Venice. Kevan Jenson is an artist and his wife, Maria, is a playwright, and they were both in urgent need of workspace their cramped bungalow lacked. X-Ten added a new living area and rear studio with a roll-up door, both of which open onto a gravel court. Steps lead up to a writer's aerie over the living room, with views out over the roofs to the Getty Center and Marina del Rey. The old house was remodeled, with existing walls retained, but the roof was raised to pull in natural light through clerestories. All that is visible from the street is a lively composition of corrugated metal walls and shed roofs set at different angles and layered front to back.

125

7 Mail-Order Idyll

"I never do residential because I believe everybody must create his own home," declares Philippe Starck. "If you hire a designer you will get a showroom and you will die. Or, worse, you will live in his brain." His clients, Camilla and Benjamin Trigano, exchange a smile. They knew Starck would give them what they needed, because they adore spending vacations in the house he built for himself on the Atlantic coast near Bordeaux. The prolific French designer sent them a sketch and this is now his home away from home when he goes to L.A.

Officially, it's a remodel, though little of the old cottage remains. The pitched roofs and black clapboards with white trim have a childlike innocence. They're a comfortable fit with the neighbors on a quiet tree-lined street, but the interior vibrates with light and color. There's a wall of lime green inside the entry, another of orange, and the spacious kitchen and dining area has lemon-yellow walls that set off the pitched ceiling and gleaming white floorboards. Three steps lead up to the eclectically furnished living room and out through expansive French doors to a deck. There's a rosy glow of pink on the staircase ascending to the master suite above the children's and guest bedrooms.

"Luxury is a good pillow and mattress and beautiful light for breakfast," says Starck. "A sense of timelessness, a little creativity, humor, poetry, and tenderness. The only ambition of this house is to express the happiness of the people who live in it." In that, he's succeeded, for the Triganos and their two small children have lived here for more than a year—longer than this peripatetic couple has ever spent in one place before. Benjamin was born in France, to the family that launched Club Med, and he runs the MB photo gallery in West Hollywood. Camilla is English, but at age seven her father moved the family to a village in the Dordogne region of France. She now manages the Starck-designed Taschen bookstore in Beverly Hills.

The furniture the Triganos brought from Paris is an odd mélange of Starck and flea-market finds—much like the mix the designer loves to use in order to annoy purists. The house shows his skill in other ways. The master bathroom comprises a separate toilet and shower with a closet between, which together form a room divider behind the bed. The deck is invisible from below and so they can soak unseen in the outdoor tub, gazing up at the sky and treetops. "All we wanted," says Camilla, "was what Philippe retreats to: a beach shack with a twist."

127

128 Venice, CA					Additions and Remodels

8 Corrugated Cube

Olivier Touraine and Deborah Richmond are another husband-wife architectural partnership who, like most of their peers, have used themselves as guinea pigs. (Touraine honed his skills working with Rem Koolhaas and Jean Nouvel.) By combining a vacant corner lot with the office they installed in a traditional house next door, they were able to get away with five parking spaces. They then restored the old house and rented it to pay for the construction of their new abode: a cube clad in corrugated metal and cut away at the top and bottom. The two upper stories are supported on four slender pipe columns and by a service/staircase core, which allows the first-floor living area to be opened up on all sides through glass and ribbed Lexan sliders. Inexpensive materials are used in inventive ways. Clear glass is shaded with Mylar drapes. Handsomely finished, light-toned Strandboard wall paneling contrasts with the same dark-toned composite on the stairs. The second floor includes a small guest room and an office that looks down over a parapet to the lofty living area. The third-floor master suite opens onto terraces, and the closets are screened off with heavy welding curtains.

9 Flexing Muscles

Gold's Gym, where Arnold Schwarzenegger trained to become Mr. Universe and appeared in *Pumping Iron*, before starring as the Terminator and becoming governor of California, relocated to larger premises in 1972. The shell was skillfully converted into a residential loft, but it fell into the wrong hands and looked like a drug den when John Betz and Heidi Roberts found it. He's a harbor pilot, she's a marketing consultant, and they had been looking for a place as appealing as their converted warehouse in San Francisco. Unable to find an architect who would bring their vision to reality, they hired architectural designer James Rennie, who had worked with Glen Irani on two commercial properties, to remodel the building while retaining its authentic character.

Rennie kept the blank street facade with the original lettering and inserted a hinged steel grille with a steel door behind. The door can be opened to admit ocean breezes while preserving privacy, though there are few pedestrians on this heavily trafficked street, and the principal entry is from an enclosed parking area on the rear alley. Most interior walls were removed to open up the lofty, skylit central void, with a few steps leading up from the living area to the kitchen and dining room. An artist friend painted a mural of the couple's previous home, at the foot of the Bay Bridge, and a Modigliani reproduction is juxtaposed with an impeccably polished surfboard as an icon of their shared loves for Paris and the ocean.

The elegant maple-framed staircase ascending to a library gallery was replicated to provide access to a guest sleeping area at the opposite side of the great room, to their child's bedroom, and to the master suite. The bathroom is treated with some ceremony: light from above bathes the mosaic tile walls, and tubular lights are suspended in front of the expansive mirror. More stairs lead up to a roof deck with a golden pavilion for shade.

134　Venice, CA　　　　Additions and Remodels

Living with Art

Art and architecture are interwoven in many of the studios and houses in Venice. A few artists have created habitable sculptures or filled their homes with work that inspires them. Venice is also fertile ground for obsessive collectors and eccentrics. One, who prefers to remain anonymous, has filled his garage with experimental German cars, turned his closet into a convincing imitation of an upscale men's store, and installed an Airstream trailer, a Gogomobile, stuffed deer, and a faux canyon on his roof deck. Here is a selection of houses where art or collectibles take pride of place, and two of the galleries that satisfy those needs.

1 Graham and Friends

In 1971, Roy Doumani, an international banker with interests in real estate, bought a plot of land at the tip of the peninsula in front of Marina del Rey and commissioned a house from architect John Lautner. When he had first seen the area as a college student, the strip of sand was a wasteland of oil wells and spills; in the '70s he was drawn by the expanse of the beach and the serenity of the ocean. But the Coastal Commission rejected Lautner's bold design, and Doumani made do with his condo farther down the beach, until he began collecting sculpture by Robert Graham. This work inspired him to consider commissioning a major piece and building a home around it. Over dinner, the artist said to Doumani and his wife, Carol, "I'll make a sculpture for you, but I'd rather design the whole house." Graham went on: "Let me create a living space for you that will incorporate art within the structure in personal, permanent, and functional ways. I'll ask my friends in the art world to work with us, to create something lasting and unique."

Graham had never designed a house before, but his confidence was infectious, and his passion for the project never wavered over the two years of planning and building increasingly elaborate models, and another two years of construction. The process was hands-on, from the first wax maquette to the integration of artworks by a roster of fifteen artists over the next two decades. Graham created a simple white rectangle, cut away on one side to produce a U-plan of interlocking, light-infused spaces on six levels. Billy Al Bengston designed a calligraphic stainless steel fence at the base, as well as inlaid kitchen cabinetry, and he recommended that the granite pavers on the main floor be laid diagonally to soften the rectilinearity of the interiors. Michael Heizer placed four massive boulders in concrete-lined pits at the foot of the steps that lead up to the stained glass and fresco by David Novros in the foyer between the two wings.

The living/dining area is raised eight feet above the sand for privacy and is overlooked by a mezzanine-level office; the two-level sitting area to the rear is lit from above. Eric Orr's waterfall eddies over the skylight, throwing patterns like lapping waves onto the white walls, and is framed by Terry Schoonhoven's mural of a sky, puffy with scudding clouds. Each of the artists worked independently, but sought to collaborate—not compete. "Let's not hang art on the walls, but allow the light to play across the surfaces," Graham said. "This is not a museum; the art should not shout out its importance but create a serene backdrop to your lives." He also counseled against bringing in a decorator, preferring that the interiors reflect the Doumanis' choices and taste rather than that of a professional eye, and that they would not diminish the impact of Larry Bell's meticulously crafted furniture, Tony Berlant's tin-clad door, and his own figurative reliefs.

"Our lives revolve around this house," says Carol Doumani, a writer who has developed a passion for art. "We began as creators, became curators, and now are custodians. We want to be sure the house survives intact when we are gone, and that's why we will bequeath it to UCLA when we die—but hopefully we will live here for many more years!"

142

143

2 Masks and Rocks

Woods Davy is a sculptor who creates arcs of rocks that seem arrested in flight, and he collects carved wooden masks from the Luba and Songye tribes in what is now Zaire. The two activities are intertwined and mutually inspiring. Finding water-smoothed stones on a beach in Baja and rough lumps of granite in a San Diego County quarry puts him in touch with nature. The quest for Kifwebe masks among the antiquarians of Brussels connects him to another culture—and to the past, for the rituals these masks served are no longer practiced. Masks and sculptures play variations on well-defined themes and each demands a gift for composition.

The architecture of the house Davy shares with his wife, Kathleen, is unremarkable, but the power of the art is overwhelming. The masks—carved, painted, and charged with magical properties by different individuals—can be as terrifying as a wild animal on the attack or as benign as a Buddha. The rock sculptures are weighty (Davy hires local gang members to move them around the house and garden, or brings a forklift through the roll-up doors of his studio), but they drift through space as airily as a stream of soap bubbles.

146 Venice, CA Living with Art

147

3 Mosaic Tile House

Working in the tradition of Sam Rodia, who created his towers in Watts from scavenged materials, single-handedly, whenever he could spare time from his day job as a plasterer, Gonzalo Duran and Cheri Pann have transformed a plain 1940s house into a jeweled cave of colored tile and splintered glass. There are a few differences: she is a painter and ceramicist; he was trained as an artist at Chouinard. The scale is domestic, allowing Duran to work with no greater support than a stepladder, and Pann fires most of the tiles, though friends bring them broken teapots, Beanie Babies, lottery cards, and other castoffs. Everything finds a place in the collage.

When they bought the house, their first task was to build a lofty studio in back. The artwork began with a bathroom, spread to the hobbit's kitchen, and gradually took over the entire house. Pergolas and richly ornamented metal gates share the front yard with eleven fruit trees. A bathtub is cut away and entwined with serpents to serve as a garden bower. Within, every surface is encrusted with ceramics, and the passion for ornament has reached beyond the studio to enrich a gazebo arching over the spa.

"I was drawn to tile work by seeing artisans doing it gracefully in Mexico, where I grew up," says Duran. "They looked as though they were having fun in the way they handled the trowel. There's an idea in my head, but I don't know how it's going to turn out until I do it. Color makes our hearts sing; it's in my DNA." The same is true for Pann, who has flame-red hair and still remembers childhood expeditions to buy colorful produce in Grand Central Market downtown.

4 Time Warp

At the north end of the Venice boardwalk are two three-story houses that interlock like the parts of a Rubik's Cube. There's even an indoor lap pool glowing softly in filtered natural light. Built in the early 1970s by architect Anthony Greenberg and producer Tony Bill for themselves, the houses have historic importance as one of the first attempts to revive the flagging fortunes of what was then a decaying slum. The present owners, retired television director Jim Johnston and producer Noelle Campbell, are peripatetic, and it's appropriate that they've amassed a collection of posters from the golden age of travel between the wars, plus models of the streamlined planes and trains that carried a privileged few to romantic destinations. Still more remarkable, their living-room balcony overlooks a stretch of beach that evokes an idealized vision of the Riviera in F. Scott Fitzgerald's day. Sipping champagne and gazing across the ocean, you wonder if you've been caught in a time warp.

5 Quirky Figures

A window frames three wooden legs kicking skyward and the rest of the facade is enigmatically blank: welcome to a magic kingdom of creative anarchy. Blaine Halvorson was trained as a graphic designer in Bozeman, Montana, runs the high-end T-shirt company Junk Food, and has a second career as an artist. Collecting is his obsession and he's filled every corner of a new house with images and figures as unique as himself, arranged with a brilliance any curator would envy. Sex Pistols memorabilia shares space with rubber and steel parachute dummies from a B52 and *santos* that have been stripped of their elaborate robes to emphasize the angelic painted heads sitting atop crude wooden frames. There's an array of metal doll molds, a fully articulated artist's model suspended from gymnastics rings, and a decaying wooden figure of a pope. A row of mesh masks worn by black stage actors passing as white casts shadows across a wall.

"I'm out of room, but I'm building a summerhouse in Montana with a studio for ten invited artists," says Halvorson, whose concept of unlimited space was derived from Big Sky country. What's remarkable is the feeling of concentration he's achieved, by playing one object off another. He's proudest of the paintings he acquired from Mark Ryden, a surrealist who invests the everyday with power and mystery, and from Camille Rose Garcia, whose intense colors and dark whimsy draw you into an alien world. But everything in the house is one-of-a-kind and the product of an artist's imagination.

159

6 Clustered Cottages

Like the late Tony Duquette, Scott Mayers creates treasures from trash, and shares the conviction of that eccentric genius that more is more. To accommodate his growing hoard of collectibles, he refurbished a row of four tiny wood-frame bungalows that open off a narrow walkway. "They were completely disheveled—friends thought I was mad to buy them," Mayers says. The first is his office—the Science of Understanding Life (SOUL) Clinic; the others separately house his bedroom, living room, kitchen, and a snug dining room in the former garage. Each is brightly painted outside and in ("I mix my own colors at Naylor's on Lincoln") and is lit and ventilated from automated skylights and windows scavenged from other houses he has remodeled. The rooms open up through folding doors to a leafy yard that doubles as an outdoor bathing area and is lit from three hundred low-voltage hanging lanterns.

Hand-thrown slag-glass vases in juicy colors fill one room, each one a different shape. Another space is given over to Mexican folk art and an old neon sign, and a guest bathroom is crammed with lead soldiers. There's barely a thousand square feet under cover, so every inch is utilized. Two giant gargoyles from the movie *Ghostbusters*, brought here at night in an open truck from a props warehouse in Watts that was torched during the 1992 riots, take pride of place. Too large to fit indoors, they preside like totems over the densely planted garden.

162 Venice, CA Living with Art

163

7 Color Field

Billy Al Bengston took another cluster of four clapboard cottages and rehabbed them to serve as a live/work space, before selling them to Melissa Mathison, a screenwriter best known for *E.T. the Extra Terrestrial*. The artist painted the exterior walls in searing tones of scarlet, yellow, and blue that transport you to a Mexican village. He even drew a plan that identified the central lap pool as the Sea of Cortez, and portrayed the triangular plot as if it were a map of Mexico. Mathison has given a cottage to each of her teenage children, and has kept the rest for herself. She was formerly married to Harrison Ford, and they are still friends, but, as she admits: "I couldn't go back to Brentwood or Beverly Hills. This is a perfect way for me to live. I can walk everywhere, and choose between a swank restaurant or a Mexican fruit stall across from the Rose Café. I call this place 'Billy,' and I've tried to preserve the mood."

8 **Glass and Fashion**

Simon Maltby is a versatile Australian-born artisan married to Swinda Reichelt, an audacious fashion designer from Berlin. They share a funky complex of live/work spaces that express and contain their varied talents. There's a stair leading up to an unrailed deck with an armchair and an upside-down chandelier suspended over the courtyard. There's a dress that's all zipper and a gossamer cocoon of a wedding gown awaiting eager buyers at the next trunk show. The derelict bungalow at the rear of the site was given a second story by builder Jan Groene, who now lives in Costa Rica, and Maltby has been improving it while executing commissions in his street-front studio. These include Dennis Hopper's tub of laminated broken glass (an object as disturbing as Meret Oppenheim's fur-lined teacup).

Maltby's masterpiece is a porch entirely composed of recycled glass raised on a steel frame above a carpet of ferns. Flax will envelop the walls and glass doors to either side open to provide cross ventilation. The dining table extends onto the porch; behind is the kitchen and sitting area with a swiveling stove. The glass-walled shower opens onto a fenced yard, and a four-poster bed is carved from driftwood. Half laboratory, half work of art, the house is a showcase for the skills of its owners.

9 Reclusive Savant

Roger Webster plays Edward Scissorhands with his nine-inch paste-on nails, stamped with black and red skulls to sharpen his carefully cultivated facade. Behind the Goth image is a gentle, reclusive savant who has dedicated his life to Venice. His father was an Oscar-winning songwriter, and Webster grew up in Beverly Hills observing the world from the family Rolls-Royce. He escaped the golden cocoon, first to Chouinard, and then to a crash pad in Ocean Park, but he made a profit in real estate while seeking to preserve old buildings. One of these, a soaring white warehouse, is his redoubt and a repository for his magpie hoard of very odd stuff. He's a compulsive photographer and, in 1968, cofounded Environmental Communications, the legendary slide library on Windward Avenue that shut down in the '80s.

"Venice is the end of the road, like Key West—a runaway place for people who hate the rest of L.A.," says Webster. "People come here to hide. Reyner Banham [the British architectural scholar] sensed it was unique and defended its value even before the people who were living here. It had been abandoned; there wasn't a middle ground or power structure. It was violent and edgy; we loved the oil pumps on the peninsula, pumping in the fog. Lots of eccentrics appreciated what an amazing resource it was. When I was on Windward, there was a guy who played the trumpet, half-naked under the arches."

170 Venice, CA Living with Art

10 **Master Printer**

Edward Hamilton perfected his skills as a printer at Cirrus Editions and Tamarind Lithography Workshop, artist-run presses in Hollywood, before opening his own lithography workshop in 1990, with the support and encouragement of Ed Ruscha. Now that Abbot Kinney Boulevard is a bustling scene, the plain white shed, open by appointment, is an anomaly—a throwback to the street's humble past. That's fine with the galaxy of local artists who work at the studio, one-on-one with the master, who understands their needs and helps them explore unfamiliar ground. "It's a collaborative relationship," says Hamilton. "I limit myself to lithographs and try to keep prices reasonable, making more prints in smaller editions, though Ed's [Ruscha] have shot up and his prints often sell out prior to publication."

Every artist has a different viewpoint and introduces different ideas. Some, like Ruscha, have everything planned out; others, like Alan Ruppersberg, have no preconceived idea. "It's essential to be able to adapt, and subordinate my way of seeing things," Hamilton says. "And yet, I've made a lot of contributions—proposing to Ed that he scratch film emulsion and that ink be left unsmoothed to leave bars of black. I put him together with Raymond Pettibon, who added satirical comments to Ed's print of a Holy Bible that seems to float above the faux linen backdrop. I also worked with Ed Moses to print a red and black litho off-register to leave cracks of white."

11 **Art Mecca**

The LA Louver recently celebrated its thirtieth anniversary as one of L.A.'s top contemporary art galleries and the only one of its caliber located in Venice. David Hockney is the best known of its roster of established and emerging talents. English expat Peter Gould established the gallery in 1976 and rapidly expanded into six scattered spaces, each with its own distinct character. To consolidate everything under one roof, he bought a vacant lot on Venice Boulevard, a half block from the beach, and wasted three years negotiating a variance on parking. Meanwhile, Frederick Fisher designed a three-story building that would capture the spirit of the spaces it superseded. Here, as in the Broad Art Foundation in Santa Monica, the architect worked almost invisibly to give art the starring role.

The concrete block and dark stucco facade incorporates a gated entry courtyard that is used for display or shipping if trucks are too large for the loading dock on the rear alley. The reception/stair hall leads into a long, open fourteen-foot-high gallery that can easily be reconfigured. The small, windowless front room can be shut off by a slider for private viewing, but it's normally used as an adjunct to the main gallery. Upstairs there's an intimate gallery and a roofless white cube that was inspired by an Ed Moses artwork in which he removed a roof a piece at a time. To the rear of the second-floor gallery is a viewing room and an archive, which are private but can be seen by visitors. The third-floor office, library, and roof terrace look out over the ocean.

176 Venice, CA Living with Art

12 Cabinet of Curiosities

At Obsolete, his gallery on Main Street, Ray Azoulay shows a wonderfully eclectic mix of old and curious artifacts and contemporary artworks. He includes artists you've never heard of and objects you could have imagined only in a demented dream. Azoulay started as a clothes designer collecting antiques as a hobby, moved from New York's East Village to Venice, and opened his gallery in 2000 in a bow-truss warehouse. "Within these four walls, I can do anything," he says. "I do a show when I feel it's time and keep it up as long as I want. I'm the only buyer and I trust my instincts. Each piece is unique and I can spend a whole day traveling in Europe or America without finding the right thing. If I find four I'm over the moon."

"Ray's a genius at spotting and arranging things," says Blaine Halvorson. "He has an incredible eye; I wouldn't know where to find these things." Halvorson and other regulars quickly snap up the best finds but the reserves seem inexhaustible. Recently the display included Harris Diamant's surreal heads assembled from eyeglasses and opticians' equipment, early ventriloquists' dummies, a model staircase, as well as Ethan Murrow's large pencil drawings of divers that resembled soft-toned photographs. Figural paintings and sculpture predominate, and the common threads are line, patina, and originality. Obsolete would be entirely at home in London, Paris, or Berlin, but it's hard to imagine it moving from Venice to another part of L.A.

180 Venice, CA Living with Art

Creative Spirits

Charles and Ray Eames—arguably the greatest design team of the twentieth century—established the Plyformed Wood Company plant at 555 Rose Avenue in 1943. Later that year they expanded into a former automobile and streetcar repair shop at 901 West Washington / now Abbot Kinney / Boulevard. The latter space was to be their creative base for forty-five years. The goal was to work long hours with no outside interference in a quest for perfection. Back then, Venice was terra incognita for most Angelenos, but it was an easy commute from the Eameses' Richard Neutra apartment in Westwood and from the steel and glass house they built for themselves in Pacific Palisades in 1949. They and their dedicated staff created iconic furniture, made short films to convey ideas and concepts, and designed exhibitions.

Their clients included IBM, GE, and Westinghouse, and when the suits from back East flew in, the Eameses were ready to fulfill their visitors' fantasies of bohemia. Their precisely ordered office was artfully mussed up. Charles would give the executive a tour; Ray would serve lunch on the patio. Questions of business were often deferred until just before the return flight. Charles died in 1978, and the studio was shut down and its contents dispersed in 1988 following Ray's death. Their legacy is still alive in the work of former colleagues and younger designers, and in the nonprofit family trust that preserves the house and operates the Eames Gallery at 2665 Main Street in Santa Monica.

The Eames Office was converted by Franklin Israel to serve as an office for design consultant Ken Bright in 1990. It will soon play a new role as the Hotel Ray, a fifty-seven-room green hotel to be designed by Belzberg Architects. The new structure will incorporate existing elements and memories and is scheduled to open in 2008.

Now, as then, Venice is about hard work as much as hedonism, but the challenge is to conceal the effort, alternating all-night sessions with surfing and hanging out with friends. Hidden away in warehouses and backyards are artisans and designers, inventors and entrepreneurs who create illusions, transform materials, and diffuse culture.

Tom Schnabel was music director of the local PBS station, KCRW, for eleven years and he still hosts his own world music program, working out of a comfortable house and studio. A Venice lifeguard in the '70s, he moved to Venice in 1987 and has put down roots. Music is his life, and his many thousand recordings are so meticulously organized that he can pluck a favorite from the shelf without searching. He listens to vinyl and CDs on big speakers in a lofty central room as if he were sitting in the second row of a club, makes a virtual trip back to pre-Castro Havana or Prohibition-era New York, and listens to drums recorded in a West African village. The whole world, past and present, is contained within these walls, but he often ventures out. "Abbot Kinney created a theme park—a forerunner of Disneyland—but it became something else," he says. "I like that it's not a plastic town; there are no mansions. It's no accident that a lot of architects live here. You park on the street and see people rather than driving into your garage and hiding from the world. Friction is a good thing—scraping up against each other makes for vitality."

Michael Fox is a polymath who may be in line for a MacArthur Foundation award. He was part of a kinetic design group at MIT and moved to Venice in 2001 "because it's close to the beach and rough on the edges." He created a piston-operated Cor-ten gate for a studio on Abbot Kinney that's now occupied by the Office of Mobile Design. He's teaching at three top schools while rebuilding his house, and his commissions range from a lift for Jerry Seinfeld's Porsche collection to a motorized toilet in a customized Greyhound bus to an interactive flower that bends over to greet little kids. These projects may lead to a hotel in New York with wands that respond to people passing by and other light-activated, robotically guided structures.

Elena Manferdini represents the new face of Venice as a congenial destination for international sophisticates. Trained as an architect and engineer in Bologna, the intellectual hub of Italy, Manferdini creates wearable architecture: second skins of laser-cut fabric, in which petals open to reveal the body and express its movements. She is, quite literally, on the cutting edge of computer-driven design: the embodiment of what Charles Eames could only dream of doing in an era when one computer filled a room.

Tony Bill, the producer who won an Oscar for *The Sting* and recently completed *Flyboys*, helped lead the revival of Venice in the '70s by moving his family and office there, and investing in property. He's since moved to an old ranch house, but still works out of a vintage office on Market that Sam Spade might have rented. "What drew me was the social mix and absence of the snob class," he says. "Also I'd rather have clean air and dirty streets than the other way around. Friends thought I was crazy, saying 'It's so far away from everything.' I can bike to work, drive my kids to school in six minutes, and walk to my airplane hangar at Santa Monica Airport in ten. I don't know where else I would go."

Jay Griffith is a prolific landscape designer with the snowy hair and wrathful gaze of an Old Testament prophet, and he rages against the commercialization of Venice. What he describes as the "polyglot mix of peoples and lifestyles in a little village" that drew him here from Hollywood thirty-five years ago is changing, and he feels betrayed. He moved to Venice at age twenty-two, using his grandmother's legacy to buy a modest cottage that formerly belonged to skating star Sonja Henie's gardener, and has since designed a hundred gardens in Venice. He transformed his own into "something out of the Devonian Age"; a peaceable kingdom with cats, dogs, opossums, raccoons, and wild rabbits happily cohabiting. Two blocks away, the open-sided structure that serves as his office is surrounded by drought-resistant plants and grasses. Walking between the spaces, Griffith has time to relish the street trees he helped to plant and to damn the intrusion of "dumb boxes and high fences." Then it's time to unwind with friends beside his outdoor hearth, as the sun sets behind a giant palm and as the lights in colored glass globes, suspended overhead like ripe fruit, cast their warm glow.

Jo Lesoine claims to be the first person in L.A. to do Venetian plaster, and her expert team, Real Illusions, offers a dazzling menu of architectural finishes. A serious accident put an end to her career as a French-horn player, and she moved from London to San Francisco for the Alexander mind-body healing technique that would help her recover. Her father had given her a paintbrush as a child, and that prompted her to study traditional techniques of marbleizing and trompe l'oeil, and to develop new ones of her own. In 1997 she began to restore a derelict Spanish-style house with a detached garage that was reputedly haunted by a woman with long dark hair. When W3 Architects started excavating the site for a new studio, they found a woman's body and, though the murderer was never found, the ghost has not reappeared. Lesoine's artistry is evident in the street fence of bowed branches she commissioned from Steve Glassman, the rich colors within the house, and the library of samples in the studio.

Matt Danciger lives in his postproduction studio, Switch, finding comfort and privacy amid the quiet frenzy of editing stations. Architect Barbara Masket transformed the bow-truss warehouse that had formerly served variously as a grocery, a karate studio, and a set for an automobile photographer. She added an enigmatic metal facade on Venice Boulevard and a steel-fenced Zen garden to the rear. A women's collective did the mural along the side. Within, curved and sliding dividers of steel, wood, and fiberglass divide up the rectilinear ground floor; a pivoting steel-backed bookcase conceals the kitchen; and velvet curtains hide a sybaritic twenty-five-seat screening room. A chandelier of carved monkeys with red shades can be raised and lowered on a pulley over an open gathering space. Perforated steel stairs lead up to a large living room tucked in like an attic below the trusses and lit from the rear and by a few skylights. The master bedroom and sitting gallery extend to the rear under a stucco ceiling that mimics the curved wooden vault.

Alan K. Barnett and Melissa Davies moved Sight Effects, a leader in the digital revolution, to the former Eames office in 2000, preserving some of the interiors that architect Franklin Israel created in 1990 for Ken Bright, a corporate design consultant who became a part of Chiat/Day. Israel's bonderized steel walls and sensuous plywood cones play off the original brick walls and bow-truss vault, and have been sensitively extended. The leafy walled patio where the staff takes its lunch is a throwback to Ray Eames's oasis. For Barnett, a South African–born immigrant and art graduate, who rented equipment in Hollywood and Santa Monica, this workshop brings everything together under one roof. It allows Sight Effects and its related companies to keep an edge in special effects for movies, commercials, and video games. Best of all, it infuses everyone with the same freewheeling spirit that earlier occupants enjoyed. "There's a sense of discovery and openness," says Barnett. "We come to work in shorts and flip-flops—never anything corporate."

John Peed calls his print graphics firm Cold Open, a slang term for opening a movie with a burst of action, and the name embodies the vibrant spirit of the movie posters and CD covers that he and his fifteen-person staff produce. In 2001, he moved from Santa Monica to the narrow three-story house that Anthony Greenberg designed for himself, and worked with David Montalba to enhance it. They added translucent acrylic and hardwood floors to soften the severity of concrete block and black-painted steel rails, but saved the complex interweaving of lofty and intimate spaces. They kept the corner balconies and treated the light wells along the blank side as Japanese-style gardens.

Jack Hoffmann heads Venice Properties, and he wears two hats: successful realtor and community activist. After dropping out of business school, he moved to Venice in the mid-1980s, and joined Tony Bill and Robert Graham in an action committee to plan street plantings and other improvements. In 1991, he commissioned a trio of unrealized houses from Philippe Starck. He's bullish on Venice, and has a soaring new office by David Montalba, but he's optimistic that the neighborhood will retain its character. "Much of the property has been controlled by the same few people for decades, and they're unlikely to sell out," he says. "A lack of parking deters chains on Abbot Kinney, and none of the big realty companies has succeeded here." He has deep roots in the community and lives on Market Street, in a brick-walled loft that Charles Ward remodeled.

Resources

On Abbot Kinney

Axe (1009; 310 664 9787) Joanna Moore has brought her scrumptious organic menu to a sparely furnished storefront that is usually thronged with eager fans.

Joe's (1023; 310 399 5811) Chef Joe Miller has expanded his destination restaurant, but there's still a line on weekends to savor innovative food in the cool, understated interior.

eQuator (1103; 310 399 5544) Philip Fracassi and Michael Deyermond sell rare literature and artbooks, displayed on custom-designed plywood shelves, in an open-fronted brick shell that doubles as a spacious art gallery.

Arch Modern (1116; 310 581 0214) Noted collector Michael Boyd focuses on iconic modern design. Open by appointment. Next door at A.K. Eleven 14 (310 729 0666), Ken Irwin offers a more eclectic choice of mid-century modern furnishings.

Strange Invisible Perfumes (1138; 310 314 1505) Alexandra Balahoutis offers signature perfumes and creates new customized fragrances in Glen Irani's exotic interior.

The Other Room (1201; 310 396 6230) Sleek sibling of Craig Weiss's wine bars in Tribeca and South Beach, this one is housed in an old brick bank building that opens up to the sidewalk.

Tortoise (1208; 310 314 8448) Takuhiro and Keiko Shinomoto created an elegant showcase for contemporary Japanese crafts, including Akira lamps and Sori Yanagi's tableware.

Double Vision (1223; 310 314 2679) Elayne Glotzer combines quirky contemporary artworks with vintage collectibles in a store that defies categorization.

Rose (1225; 310 399 0040) Mark Rose came from Iowa and works with local artists and designers to create costume jewelry and other collectibles, mostly on a very small scale.

Pamela Barish (1327; 310 314 4490) Designer Pamela Barish designs chic, sexy clothes in vibrant fabrics, combining sophisticated tailoring with a strong infusion of hip.

Hal's Bar & Grill (1349; 310 396 3105) With good Venice art on display and live jazz on Sunday and Monday evenings, this local institution serves well-prepared basics every day.

Shima (1432; 310 314 0882) Inventive Japanese food, including brown rice sushi, is served in Robert Tibedou's minimal two-story restaurant; Eames furnishings add local flavor.

The Brig (1515; 310 399 7537) John Friedman and Alice Kimm have given David Reiss's funky bar a sleek new look, but it retains its boxing mural and beat-up sofas.

Off Abbot Kinney

Chaya Venice (340 Main Street; 310 396 1179) In this third of a trio of acclaimed Asian-eclectic restaurants, the stylish interior decor by Grinstein Daniels has worn well for twenty years.

Rose Café (220 Rose Avenue; 310 399 0711) Manhar Patel gave up engineering to open this welcoming local institution in 1979, commissioning murals from Rene Holovsky.

Groundworks Café (671 Rose Avenue; 310 396 9469) There are organic coffees and teas in bins and jars and a good neighborhood vibe in this white brick store. Don't miss the sign in the front yard, two doors west.

Obsolete (222 Main Street; 310 399 0024) see pages 178–181.

LA Louver (55 N. Venice Boulevard; 310 822 4955) see pages 174–177.

Small World Books (1407 Ocean Front Walk; 310 399 2360) Mary Goodfader's well-stocked store is located behind the touristy Sidewalk Café.

Events + Institutions

Venice Art Walk (venicefamilyclinic.org) For one weekend in late May, artists open their studios and donate work for auction to benefit the Venice Family Clinic, an event that is now in its twenty-eighth year. Tours of new houses are also offered.

Venice Garden and Home Tour (venicegardentour.org) Jay Griffith helped establish this annual benefit in early May for Las Doradas Children's Center.

Beyond Baroque Literary Arts Center (681 Venice Boulevard; beyondbaroque.org) L.A.'s longest-running free poetry workshop, established in 1968, is located in the Art Deco Venice City Hall. There are frequent public readings and events, and a library of small-press poetry books and broadsides.

Social and Public Art Resource Center (sparcmurals.org) WHY Architects are remodeling the police station and jail next door to City Hall for this association of Chicano mural painters, and its director, Judith F. Baca.

Venice Community Trust (venicecommunitytrust.org) Art dealer and activist Aldis Browne has ambitious plans to organize an annual arts festival, produce educational DVDs for local schools, and document the artistic heritage of the community.

Acknowledgments/ Credits

All of the artists, architects, and other creative people featured in this book provided valuable insights. My thanks to these collaborators and my apologies for having to compress their ideas and anecdotes. I'm particularly grateful to Jack Hoffmann, Henry Hopkins, and Tibby Rothman for their suggestions and introductions. This book should be dedicated to Abbot Kinney, whose vision of a community dedicated to pleasure and the arts has finally been realized. —M.W.

I would like to thank all the people of Venice who so graciously opened their homes to me and made this project a wonderful working experience. Among others I would like to thank Steven Ehrlich, whose helpful support was there from the conception of the project. Thanks to Eric Himmel for making this book possible, and to Deborah Aaronson for her openness and editorial talent. A special thanks to my wife, Jeannie Winston Nogai, for her support and collaboration during the course of the book. —J.N.

Page 9 Vintage postcard courtesy of Tony Bill; Page 14 Artists at Ferus Gallery © Patricia Faure; Page 14 Portrait of Robert Irwin © Dennis Hopper; Pages 41, 42, 82 Photographs © Juergen Nogai and Julius Schulman; Page 183 Charles and Ray Eames © Eames Foundation

Index

A
Abbot Kinney Boulevard, 56, 110, 172, 183, 184, 186
AdamsMorioka, 106
Alexander, Peter, 13, 24
al-Hassoun, Faiza, 50
Altoon, John, 13
Arnoldi, Chuck, 7, 13, 17, 23, 76
Art Walk, 19
Attaway, William, 20
Azoulay, Ray, 178

B
Baldessari, John, 18
Ballard, Carroll, 54
Banham, Reyner, 168
Barnett, Alan K., 186
Beat Generation, 11, 13, 76
Beaucage, Edith, 40
Bell, Larry, 13, 14, 15, 138
Belzberg Architects, 183
Benchley, Robert, 10–11
Bengston, Billy Al, 13, 14, 15, 138, 164
Berger, Shelley, 48
Bergman, Brenda, 98
Berlant, Tony, 13, 24, 138
Berman, Wallace, 13
Betz, John, 132
Bill, Tony, 27, 152, 184, 186
Bleifer, Ken and Sandy, 30, 34
Blum, Irving, 14
Borofsky, Jonathan, 25, 27
Bright, Ken, 183, 186
Broad Art Foundation, 174
Brooks, Angela, 102
Bruggen, Coosje van, 25

C
Caland, Huguette, 18
California Coastal Commission, 25, 138
Callas Shortridge Architects, 114
Campbell, Noelle, 152
Caplin, Loren and Anne-Laure, 27, 30
Charca, Bernardo, 118
Chiat, Jay, 24
Chiat/Day, 24–25, 27, 186
Chouinard, 13, 148, 168
Cirrus Editions, 172
Cold Open, 186
Conner, Bruce, 14
Coop Himmelb(l)au, 8, 66

D
Danciger, Matt, 185
Danziger, Lou, 23
Davies, Melissa, 186
Davis, Ron, 23
Davy, Woods and Kathleen, 144
Dean, James, 76
Demarchelier, Patrick, 19
De Stijl, 60
Diamant, Harris, 178
Diebenkorn, Richard, 13
Dill, Guy, 13, 17, 23
Dill, Laddie John, 13, 17, 19, 23, 76
di Suvero, Mark, 7
Doumani, Roy and Carol, 138
Duke Ellington memorial (NY), 20
Duran, Gonzalo, 148
Duquette, Tony, 160

E
Eames, Charles and Ray, 56, 110, 183, 184, 186
Ehrlich, Steven, 82, 86, 88
Eizenberg, Julie, 34
Electric Avenue, 13, 34
Ennis, Thomas, 60
Environmental Communications, 168

F
Faure, Patricia, 14
FDR Memorial (D.C.), 20
Ferus Gallery, 13–14, 76
Fisher, Frederick, 27, 30, 174
Fong, Stacy, 88
Ford, Harrison, 164
Fox, Michael, 184
Francis, Sam, 76

G
Garcia, Camille Rose, 156
Gas House, 11

Gehry, Frank, 8, 15, 16, 17, 23–25, 27, 54, 76, 110
Gemini GEL, 17, 23
Glassman, Steve, 185
Gold's Gym, 132
Gould, Peter, 174
Graham, Robert, 20, 21, 138, 186
Greenberg, Anthony, 152, 186
Griffith, Jay, 72, 114, 185
Groene, Jan, 166

H
Haefelfinger, Monika, 122
Hall, D.J., 20
Halvorson, Blaine, 156, 178
Hamilton, Edward, 172
Hampton Drive, 13
Hansen, Lynne, 19
Hayes, Cornelia, 94
Heizer, Michael, 138
Henie, Sonja, 185
Herms, George, 13, 76
Hertz, David, 56, 60, 88
Herzog & de Meuron, 122
Hockney, David, 110, 174
Hoffmann, Jack, 186
Hollis, Catherine, 44
Hopkins, Henry, 13–14
Hopper, Dennis, 7, 14, 23, 76, 166
Hopper, Victoria, 76
Hopps, Walter, 14
Hotel Ray, 183
Hricak, Michael, 66
Hulten, Pontus, 14
Huston, Angelica, 20

I
Innes Place, 13
Irani, Glen, 40, 132

Irwin, Robert, 13, 14
Isozaki, Arata, 8
Israel, Franklin, 114, 183, 186
Israel, Michael and Judy, 34

J
Jenson, Kevan and Maria, 122
Johnston, Jim, 152
Johnston, Sharon, 27
Junk Food, 156

K
KCRW, 183
Kelly, Austin, 122
Kienholz, Ed, 14
Kinney, Abbot, 9–10, 11, 39, 48, 183
Klosterman, Kristin, 19
Koning, Hank, 34
Koolhaas, Rem, 130

L
L.A. Fine Arts Squad, 11
LA Louver, 174
Lautner, John, 138
Lee, Mark, 27
Lesoine, Jo, 185
Light and Space movement, 14
Lin, Maya, 8–9
Lincoln Boulevard, 11, 160
Lipton, Lawrence, 11
"Los Angeles, 1955-1985," 14
Los Angeles County Museum of Art, 15
Lynn, Greg, 9

M
MacArthur Foundation, 184
Mack, Mark, 50
Main Street, 24, 34, 178, 183

Maltby, Simon, 76, 166
Manferdini, Elena, 184
Marder, Bruce, 24
Market Street, 13, 15, 25, 27, 184, 186
Marsh, Norman F., 9
Masket, Barbara, 185
Mathison, Melissa, 164
Mayers, Scott, 160
Mayne, Thom, 8, 27
MB photo gallery, 126
Medavoy, Mike, 76
Meier, Richard, 40
Mildred Avenue, 13
Minnelli, Liza, 27
Moede, Virginia, 66
Montalba, David, 186
Moore, Dudley, 27
Morioka, Noreen, 106
Morphosis, 8, 26, 27
Morrison, Jim, 54, 60
Moses, Ed, 16, 24, 172, 174
Moss, Eric Owen, 122
Mundwiler, Stephan, 98
Munoz, Juan Carlos, 21
Murphy, Brian, 76
Murrow, Ethan, 178
Myers, Barton, 106

N
Neutra, Richard, 183
Nin, Anaïs, 48
Norton, Bill and Lynn, 23, 54
Norton Simon Collection, 14
Nouvel, Jean, 130
Novros, David, 138

O
Obsolete, 178
Ocean Front Walk, 11, 29
Office of Mobile Design, 110, 184
O'Herlihy, Lorcan, 94

Okulich, John, 13, 19
Oldenburg, Claes, 25
Oppenheim, Meret, 166
Orr, Eric, 110, 138
Otis (art school), 13

P
Pacific Avenue, 29
Pann, Cheri, 148
Pasadena Museum of Art, 14
Peed, John, 186
Performing and Visual Arts Academy, 66
Pettibon, Raymond, 172
Playa Vista, 24
Plyformed Wood Company, 183
Portable House, 110
Predock, Antoine, 56, 66
Price, Ken, 13, 15, 16
Pritzker Architecture Prize, 8, 23
Prix, Wolf, 66
Pugh + Scarpa, 102
Pynchon, Thomas, 11

R
Real Illusions, 185
Rebecca's restaurant, 23–24
Rebello, Stephen, 11
Reichelt, Swinda, 166
Rennie, James, 132
Richmond, Deborah, 130
Rivera, Diego, 21
Roberts, Heidi, 132
Robins, Shari Lynn, 106
Rodia, Sam, 148
Rose Avenue, 183
Rosen, Michael and Susan, 72, 76
Rotondi, Michael, 27
Runyon, Damon, 15

Ruppersberg, Alan, 172
Ruscha, Ed, 13, 15, 172
Ryden, Mark, 156

S
Saarinen, Eric and Nancy, 56
Saee, Michele, 48
Sale, Joshua, 27
Sander, Whitney, 44
Scarpa, Lawrence, 102
Schmitz, Lothar, 48
Schnabel, Tom, 183
Schnidler, R. M., 60
Schoenstadt, Kim, 18
Schoonhoven, Terry, 10, 138
Schwarzenegger, Arnold, 132
Science of Understanding Life (SOUL) Clinic, 160
Seinfeld, Jerry, 184
Serra, Richard, 25
Shinomoto, Takuhiro, 106
Shortridge, Steven, 114
Siegel, Jennifer, 110
Sight Effects, 186
Simon, Norton, 23
Siqueiros, David, 21
Skidmore, Owings & Merrill, 40
Smith, Alexis, 16
Southern California Institute of Architecture, 118
Spiller, Jane, 23, 24
Stanton, Jeffrey, 10
Starck, Philippe, 66, 126, 186
Stockwell, Dean, 76
Switch, 185

T
Tamarind Lithography Workshop, 172

Touraine, Olivier, 130
Trigano, Camilla and Benjamin, 126
Tso, Roland, 66
Turrell, James, 13, 14

U
Unger, David and Melissa, 86

V
Valentine, DeWain, 13
Varda, Agnès, 11
Venice, Italy (La Serenissima), 7, 10–11
Venice Biennale (1985), 25
Venice Boulevard, 11, 24, 174, 185
Venice of America: Coney Island of the Pacific (Stanton), 10
Venice Properties, 186
Voulkas, Peter, 13

W
W₃ Architects, 185
Walt Disney Concert Hall, 23
Ward, Charles, 72, 186
Warhol, Andy, 76
Watson, Toby, 20
Weber, Bruce, 19
Webster, Roger, 168
Welles, Orson, 11
Wheeler, Doug, 14
Wilder, Eddie de, 14
Windward Avenue, 9–10, 168
World's Columbian Exposition in Chicago (1893), 9

X
X-Ten, 122

Designed by Brankica Kovrlija

Library of Congress Cataloging-in-Publication Data

Webb, Michael, 1937-
 Venice, CA : art + architecture in a maverick community / text by Michael Webb ; photographs by Juergen Nogai.
 p. cm.
 Includes index.
 ISBN 10: 0-8109-9306-6
 ISBN 13: 978-0-8109-9306-8
 1. Art, American—California—Los Angeles. 2. Architecture—California—Los Angeles. 3. Venice (Los Angeles, Calif.) I. Nogai, Juergen. II. Title.

N6535.L6W43 2007
709.794'94—dc22
 2006034572

Text copyright © 2007 Michael Webb
Photographs copyright © 2007 Juergen Nogai

Published in 2007 by Abrams, an imprint of Harry N. Abrams, Inc. All rights reserved. No portion of this book may be reproduced, stored in a retrieval system, or transmitted in any form or by any means, mechanical, electronic, photocopying, recording, or otherwise, without written permission from the publisher.

Printed and bound in China
10 9 8 7 6 5 4 3 2 1

HNA
harry n. abrams, inc.
a subsidiary of La Martinière Groupe

115 West 18th Street
New York, NY 10011
www.hnabooks.com